GETTING STARTED IN
AIRBRUSH

DAVID MILLER & DIANA MARTIN

NORTH LIGHT BOOKS

CINCINNATI, OHIO

Permissions

pp. 79, 84 © by Cincinnati Milacron. Artist: Jim Effler. Used by permission.

pp. 20, 23, 30, 35, 42-43, 46-47, 54-55, 65 © by Jack Whitney, Whitney Illustration. Used by permission.

pp. 11, 18-19, 22-23, 30-31, 35, 42, 47, 54-56, 69, 64-65, 74-75, 96 © by Jim Effler. Used by permission.

pp. 14-17, 24-27, 31, 52-53, 55, 69, 75, 85, 89, 92-95, 96, 109 © by Ed White. Used by permission.

pp. 19, 79, 85, 89, 109 © by Joseph H. Taylor. Used by permission.

p. 101 © by Tom Rogouski, Tom Rogouski Photography, Inc. Used by permission.

p. 89 © by AIR Studio. Artist: Dan Shannon. Used by permission.

pp. 86, 97 © by AIR Studio. Artist: Phil Stephens. Used by permission.

pp. 22, 30, 59, 64, 66, 74, 85, 96 © by AIR Studio. Artist: Toby Lay. Used by permission.

Other fine North Light Books are available at your local bookstore, art supply store or direct from the publisher.

04 03 02 01 00 11 10 9 8 7

Library of Congress Cataloging-in-Publication Data
Miller, David
 Getting started in airbrush/David Miller & Diana Martin.
 p. cm.
 Includes index.
 ISBN 0-89134-479-9
 1. Airbrush art—Technique. I. Martin, Diana
 II. Title.
 NC915.A35M56 1993
 741.6—dc20
 93-682
 CIP

Edited by Perri Weinberg-Schenker
Designed by Carol Buchanan
Cover illustration by David Miller

Acknowledgments

A very special thank you goes to
Ed White, a Cincinnati-based
illustrator, whose contribution and
enthusiasm are greatly appreciated.

Introduction

Chapter One:

GETTING STARTED...2

What you need to get started in either commercial illustration or T-shirt art, including...
- equipment and materials
- how to fix clogging, spidering and other airbrushing problems
- special effects techniques
- getting from idea to drawing to money-making art

Chapter Two:

AIRBRUSHING FREEHAND...8

Learn how to airbrush without masks or stencils and...
- work faster and more creatively
- render soft, diffused effects
- spray a variety of strokes

Demonstrations

Flamingo Heart—Airbrush a popular, colorful image

Hot & Spicy (Lettering)—Combine block and script lettering styles

Professional Portfolio

Chapter Three:

GRADATING COLOR...20

Master the technique for gradating colors so you can...
- render dramatic backgrounds, skies and sunsets
- use color to give shape to an object
- add depth to your work

Demonstrations

Painted Desert Scene—Color gradation produces a dramatic sky, horizon and foreground

Red Rose—Develop subtle shadow gradations to shape and add depth

Professional Portfolio

Chapter Four:

USING MASKS...32

Discover all the masking techniques, materials and their uses. Learn how to...
- render different edge effects
- spray highlights, shadows and dimension
- define shapes and patterns
- create a sense of movement

Demonstrations

Pretty Woman—Use masking to build color, tone and value

Jet Skier—Combine masks with freehanding to illustrate high-speed action

Professional Portfolio

Chapter Five:

CREATING EDGE EFFECTS...44

See how to use different edge effects to create the type of image you want. Learn how to...
- render soft, diffused or hard edges with and without masking
- create photorealistic, highly stylized or ultrasoft artwork

Demonstrations

Romantic Walk on the Beach—Create hard, soft and diffused edges and a stippled texture

Tropical Parrot—Show motion by combining hard and soft edges in T-shirt art

Professional Portfolio

Chapter Six:

RENDERING TEXTURE...56

Discover the broad range of techniques used to render any texture imaginable, including...
- wood grain
- hair and skin
- cork and glass
- marble and liquid

Demonstrations

American Eagle—Render a complex feather texture with hard edges

Champagne Splash—Airbrushing translucent liquid and glass

Professional Portfolio

Chapter Seven:

APPLYING HIGHLIGHTS...66

Become skilled at putting sparkle and polish into your illustrations. Learn how to...
- produce different kinds of highlights
- combine airbrush with handbrush and erasure for ultimate highlighting

Demonstrations

Pool Toy—Layer highlights to create depth
Mercedes Hood Ornament—Use dramatic highlights and reflections to render shiny chrome and painted metal
Professional Portfolio

Chapter Eight:

CREATING METALLIC EFFECTS...76

Discover the secrets to making metallic effects look real—and really outstanding—with...
- strong contrast between lights and darks
- gradated color that reflects the color of objects nearby
- shiny, bright highlights
- reflective horizon lines

Demonstrations

Golden Lettering—Make metallic lettering as brilliant as genuine 14-carat gold
Hot Caddy—Sky and ground reflections on its shiny, colored surfaces make this hot car look real
Professional Portfolio

Chapter Nine:

RENDERING LETTERING...86

See how the airbrush lets you produce a variety of lettering styles, including script, bubble, metallic and neon. Also discover...
- unique techniques and materials
- ways to ensure proportion and consistency in your letters

Demonstrations

Love in My Heart—Produce popular neon lettering
Elvis and TCB—Use drop shadows to elevate script lettering off of the T-shirt surface
The Doors—Apply brilliant reflections to block lettering
Professional Portfolio

Chapter Ten:

HANDTINTING PHOTOGRAPHS...98

Experience the fun of transforming a realistic photograph into a creative canvas of fantasy and color. Learn how to...
- add the right amounts and kinds of color to get different effects
- deftly cut masks without cutting the photo
- push your masking skills to the max

Professional Portfolio
Demonstrations

Beach Boy—Handtint with two colors
Wild Man—Handtint with seven colors

Chapter Eleven:

RETOUCHING PHOTOGRAPHS...106

Master the art of retouching your own or others' black-and-white photos. See...
- how to fix photos by removing defects or blemishes
- how to improve the separation of a subject from its background
- ten retouching tips that ensure success

Professional Portfolio
Demonstrations

Hot Bike—Eliminate unneeded or distracting elements
Commercial Jet—Define important objects and lessen contrast
Perfect Portrait—Remove unattractive shadows and skin tones in a portrait

Where to Look for More Information...118
Index...120

David Miller is a partner in A.I.R. Studio, a highly successful illustration studio in Cincinnati for over ten years. He is coauthor of the best-selling *Dynamic Airbrush*. Before starting his illustration business in 1982, he attended the Art Academy of Cincinnati, studied airbrush rendering and photo retouching, and worked as a staff illustrator for a full-service art/design studio. His work has won art directors' and advertising club awards and is reproduced on all forms of printed media regionally and nationally. David is represented in New York City by American Artists.

Diana Martin is a freelance writer and editor based in Cincinnati. She has developed and edited ten books and workbooks on airbrushing, many of which sell internationally. She is coauthor of *Fresh Ideas in Letterhead and Business Card Design* and is at work on yet another airbrushing book. Prior to becoming a full-time freelancer she was senior editor of graphic design books for an international publisher and staff photojournalist on a number of daily papers.

INTRODUCTION

For many airbrush artists, the desire to airbrush begins with their first exposure to the technique. There is a hypnotic quality about airbrush art in the making: The artist's hands seem to float above the painting surface as he draws—with *air*—some of the most wonderful designs in the most vivid colors imaginable.

Perhaps you don't think of yourself as an artist yet. But you've been touched by the magic of airbrush, by the marriage of air and paint. As you attempt this art, the airbrush—at first frustrating and mechanical—will seem far from being your friend. The magic will likely wear off and be replaced by respect for the artist who has mastered control of this tool. But then one day it happens: Your efforts are rewarded as you achieve the same level of control. Your hands float, you draw with air—and you stop thinking about the airbrush and start thinking instead about the painting.

This book will get you started in airbrush by explaining, with easy step-by-step instruction, the techniques and tools used to build an airbrush painting. It will show you everything you need to begin, and to grow, as an airbrush artist: materials, ideas, inspiration, techniques and projects. You will come to understand the basics of the most important airbrushing techniques. You also will learn which materials to purchase first; where to look for ideas and inspiration; how to plan and develop your sketches; how to transfer sketches to the painting surface; which techniques to use for certain effects; which commercial applications are appropriate for specific techniques and how to re-create twenty-two professional projects.

As you become more involved with airbrushing, you will be amazed at the versatility of the brush in rendering a wide variety of images. You will begin to envision your own unique interpretations brought to life with air and paint. Your creativity supplies the magic; the only boundary is the limit of your imagination.

Chapter 1 GETTING STARTED

The airbrush is a magical tool that lets you turn an ordinary drawing into a rich mosaic of colors, shapes, edges and textures. As an artist, you'll enjoy more creative benefits with the airbrush than with any other artist's tool. With practice you will be able to render rich, brilliant colors or soft, pastel tints; crisp, clean edges or soft, diffused gradations; fine textural details or sweeping expanses of color.

The broad range of airbrush effects makes it possible to render anything imaginable, in any illustration style, on many different surfaces, including the illustration board and cotton T-shirts featured throughout this book.

Getting Started in Airbrush is designed for you, the aspiring airbrush artist, who wants to discover dozens of techniques, tips and projects that will be of great value as your skills develop.

How Commercial Illustration and T-Shirt Art Differ

Some of you may be attracted to both commercial and T-shirt art, which is fine. As a beginner, though, you should give all of your attention to just one area, since airbrushing techniques differ between board and T-shirt work.

Another major difference between these illustration genres is that the commercial illustrator, working from a studio, provides a service for a client who has commissioned the illustration and will use it for advertising or promotion. The T-shirt artist, on the other hand, usually works in a public "retail" situa-

tion and sells T-shirts directly to a customer.

You can choose from many paints for commercial work; T-shirt art is limited to acrylic fabric paint. When you airbrush onto a board the paint isn't absorbed into the surface the way it is on a T-shirt. This reaction affects, then, the techniques you use and the finished look you achieve. You'll see these techniques in action throughout this book.

Choosing the Right Airbrush

There are three kinds of airbrushes used for commercial and T-shirt art: single-action, double-action and turbo. Of the three, the double-action airbrush offers you the best spraying options at a reasonable price. While the single-action is the most affordable, its use is limited and might quickly frustrate you. The turbo is the most expensive and works best for detail work.

Whether you are spraying on illustration board or fabric, the double-action airbrush lets you create a great range of effects and textures just by controlling the airflow, the amount of paint sprayed, and how close you hold the brush to the surface. It lets you spray lines that are broad or thin, cover large areas, gradate color and do fine detailing.

Commercial illustrators usually own one double-action airbrush and may have a turbo handy for detail work. The commercial illustrator's brush usually has a paint cup attached to the brush. To change paint, you simply clean out the cup, spray water through the brush to clean it, and add the next color.

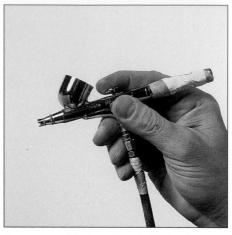

The commercial illustrations in this book were rendered using the Iwata model HP-C. Like many commercial illustrator's brushes, this one has an attached paint cup. The tape wrapped around the handle provides the artist with extra comfort.

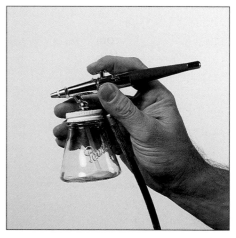

This Paasche model VL airbrush was used to create the book's T-shirt illustrations. Unlike the Iwata brush above, the T-shirt artist's brush uses paint jars that you attach and change at will. Notice how both brushes are held as you would hold a pencil, with the forefinger placed on the trigger to control air and paint flow.

Professional T-shirt artists, who need to produce finished T-shirts very quickly, may have two to three dozen airbrushes at hand so they don't have to repeatedly clean brushes to change paint colors. The expense puts this practice out of reach for most beginners. You *can* work successfully with one airbrush, but be prepared to clean your brush and change colors often.

As your skills and finances improve, you can purchase additional airbrushes. For T-shirt art you'll find that four airbrushes let you effectively use four common paints: black, white, one warm color and one cool color. If needed, you can easily clean the warm or cool color brush to introduce a new color.

Picking the Best Air Source

Commercial and T-shirt artists rely on the same sources of air to power their airbrushes. Base your own choice of air source on your budget and working environment—for example, is electricity available? An air source must be compatible with your brush so it delivers clean, dry air. Check a local airbrush supply house for manufacturer information on air sources.

CO₂ Tanks. A CO_2 tank is the best choice for the beginning airbrush illustrator with a limited budget. Tanks are quiet, clean and their air is dry. One 15-pound tank will give you about twenty to thirty hours of air,

Tips for Choosing an Airbrush

1. Ask your art supply dealer what spray patterns a brush will give you. Buy a brush that is versatile and sprays both fine and wide lines. Make sure it gives you a consistent stippled effect.
2. Hold a brush before buying it. It shouldn't feel too heavy and your fingers shouldn't feel cramped.
3. Ask your dealer if you can borrow a demo model so you can test it.
4. Buy the best brush you can afford since the more expensive brushes are built better and are more versatile than lower-end models.

depending on your frequency of use. A T-shirt artist working eight hours a day may refill every two to three days. Along with a tank, you'll need a moisture separator and a pressure regulator. The regulator needs two gauges, one showing gas and the other showing the pressure you are using. You'll need about 20 to 30 psi (pounds per square inch). Before purchasing a tank, consider testing the air source by renting one from a local welding or beverage supply company.

Silent Compressor. This compressor is, without question, expensive. You should be very committed to airbrushing before purchasing one. If you can afford one, the investment is worth it. Begin with a ⅛-hp motor, which is enough to pressure a single airbrush. With more horsepower you can power more brushes. Silent compressors are either oil-lubricated or oilless, the latter being the high-end models. A lower-end oil-lubricated compressor can work well for you as a beginner as long as you maintain it properly. Whichever model you choose should have a

regulating gauge, a moisture trap and a storage tank. Avoid purchasing a compressor from an art supply store where prices tend to be high. Check your local hardware or home supply store for a better value.

Spare Tires. A spare tire as an air source must include the inner tube and rim. Purchase a special adapter that fits the tire's valve and connects to an air hose. The problem with the spare tire source is the air pressure drops constantly, and the air can be damp and dirty. These disadvantages outweigh its availability and affordability.

Compressed Air Cans. This air source is expensive to use for very long; consider it only for short-term use. The cans are filled with an inert gas, and because of this they sometimes freeze as you use them. Freezing will reduce or cut off your air supply and your painting until the first thaw.

Diaphragm Compressor. This type of compressor seems appealing to the beginner, but it's wrought with disadvantages. Diaphragm compressors typically sold to artists have no holding tank, so they're noisy, they pulsate and they can even "dance" as you spray. These compressors usually are marketed to the hobbyist, not the professional airbrush artist. If you buy one, you can lengthen the motor's life with the purchase of an automatic shutoff valve.

Using Your Air Source. Airbrush manufacturers recommend certain pressures for their brushes that, if used all the time, will likely give you some unsatisfactory results. Whichever air source you choose, experiment and practice varying air pressure to learn how to render the range of airbrush

effects described throughout this book. Professionals use pressures ranging from 1 to 50 psi for different effects. To begin, use these guidelines:

- 25 psi for straight lines and backgrounds
- 40 psi for an extremely smooth, highly pigmented spray when using opaque paints such as gouache
- 16 psi for fine line work with transparent paints such as watercolor

How Close to the Surface to Work

To determine the correct distance from the painting surface to spray, you must develop a "feel" for the painting conditions. Three major factors determine distance: the line weight you want to achieve, the consistency or mix of the paint and the amount of air pressure. For fine line work, use a thin paint mix sprayed from about one-fourth to one-half inch from the surface at an air pressure of 15 psi. To spray a background, use a thick paint mixture and 40 psi of air pressure. The distance you hold the brush from the surface will vary depending on the size of your illustration. In general, hold the brush from six to ten inches from the surface. Keep in mind that the type of airbrush you use and the absorbency of the painting surface also will affect how close you should work. With practice, you'll quickly learn the best spraying distance.

Paints for Commercial Illustration

Artists choose from four kinds of paint—gouache, watercolor, dye and acrylic—for commercial illustration. When choosing a paint for an illustration, you should know how it will work in your airbrush, on the painting surface and with other mediums, such as colored pencil.

The Golden Rule of Airbrushing

To produce good-quality steady lines and tones, follow this golden rule of airbrushing: air on first, off last. Begin your spraying motion ahead of your actual target area by depressing the trigger for air only. As the nozzle reaches the target area, draw the trigger back for paint. When you reach the target end point, shut off the paint flow but keep the air flowing just beyond the edge of your target area.

Gouache. As a beginner, gouache is your best choice because it's readily available, forgiving and easy to clean up. Many projects in this book feature gouache so you can see how it works. This paint is very opaque when applied heavily. The effect is a silk-screen look. The opacity of gouache is useful if you need to rework a portion of an illustration. It will cover the offending area completely, letting you start over. By thinning gouache with water, you can also create a translucent, luminous look for a "tinted" effect.

Since gouache is made from finely ground pigment, you won't experience many clogging problems. The result will be a more consistent spray. These paints are moderately priced and fast drying. Be careful with a gouache illustration; its water-based quality makes it easily susceptible to scratching or chipping.

Watercolor. Watercolors are an expensive medium. They tend to be bright and produce nice, even tones, which makes them ideal for transparent layering of colors. When sprayed on illustration board, the white surface shows through the transparent paint and makes the color more brilliant. Watercolor generally doesn't cover other paint col-

ors well. The finely ground pigment lets the paint flow without clogging.

Dye. Dye is a more transparent, purer color mix than watercolor. It has less grain or opacity and so can be sprayed over gouache for a good effect. Dye, however, isn't without its faults. If you need to cover a dye color because of an error, you'll be challenged since the dye stains and will probably bleed through the covering color. Keep an eye on these brilliant paints, as they tend to bleed under self-adhesive frisket film masking and may not reproduce in print faithfully.

Acrylic. Acrylic paint offers advantages for the beginning airbrush illustrator, who tends to spray multiple layers of color. Layers of acrylic won't flake or peel, and generally this paint is the most durable of all. But be careful—this paint is likely to clog your airbrush unless it is thinned considerably.

Other Mediums. Colored pencil is a versatile medium, especially useful for rendering hair, grass, skin, building surfaces and woodgrain. To blend colored pencil with your airbrush work, lightly rub a cotton swab over the pencil work to soften its edges. If you are using frisket film for masking, apply the pencil last or the frisket will pick it up.

White paint is a must-have for tinting, blemish cover-up, detailing and highlighting. Apply white paint with the airbrush or a handbrush. The opacity of permanent white gouache makes it best for covering other paint colors, detailing and highlighting. Zinc white is suitable for tinting since it mixes well with other paints without degrading their colors.

Paints for T-Shirt Art

Make sure you buy acrylic fabric paint; once it's dry it won't wash out. (Enamels may crack when dry.) Begin with standard colors: red, blue, green, yellow, black and white. White is a particularly useful color to keep at hand, since it will cover painting "mistakes." You can create additional colors by overspraying colors on the T-shirt.

Don't buy more than a six-month supply of paint; the older the paint, the more likely it is to clog your brush. Store the paint in color jars (available at art supply stores) that snap onto the bottom of the airbrush and are interchangeable from brush to brush. Periodically strain the paints in the jars to keep them fluid and to prevent clogging. Don't let the paint get hot since this causes it to thicken, expand and potentially run up and out the jar openings.

Painting Surfaces for Commercial Illustration

Smooth-surface (hot-press) illustration boards, which have little surface variation and withstand techniques such as erasure, are the best surfaces for glossy-looking images with hard edges. Airbrush paper has the same type of smooth surface as the hot-press board and produces similar hard edges. Soft-edged images are more easily achieved on textured (cold-press) board. Frisket film masking may be used over painted board or paper areas without the risk of removing paint from the surface. You shouldn't, however, leave frisket on illustration board or airbrush paper for more than two days because paper fibers on the surface can be pulled up when you remove the frisket. Some smooth-surface boards will tolerate moist removal of paint (that is, carefully wiping or lift-ing paint from the board surface with a soft, damp rag). Ask your art supply dealer for specific characteristics of the board or paper you buy.

Painting Surfaces for T-Shirt Art

The best fabric for airbrushing is new, 100 percent cotton because it absorbs paint well and gives a fine, silky surface. In a commercial setting, however, most illustrators use a cotton-polyester blend. The T-shirt demonstrations in this book were rendered on such blended fabrics.

About Masks

A mask is any material used to protect the areas surrounding an exposed area to be painted. The mask keeps paint overspray from contacting the illustration surface where it's not desired. They also create the hard edges in an illustration when the mask is removed.

Masking for Commercial Illustration.

Self-adhesive frisket film and clear acetate are the two most widely used masking materials for commercial illustration. Liquid frisket is also convenient for rendering textures.

All of these materials can be purchased at local art supply stores. For more on masking of commercial illustration see chapter four.

Masking for T-Shirt Art. T-shirt artists have had to master freehanding to produce painted shirts quickly. Masks for T-shirts are usually called "stencils" and common stenciling materials are high-impact polystyrene plastic, vinyl, pellon and lightweight cardboard. A lot of T-shirt airbrushing is done without masks, using freehand spraying instead. Masking slows the painting process, but beginners sometimes use masks until freehanding skills develop. See chapter four for more information.

Other Equipment for All Airbrush Artists

The following are items all airbrush artists need.

Water Jug and Spray Bottle. A common problem illustrators face is airbrush clogging. Keep a water jug and spray bottle nearby to clean out your brush. Create a cheap jug by cutting

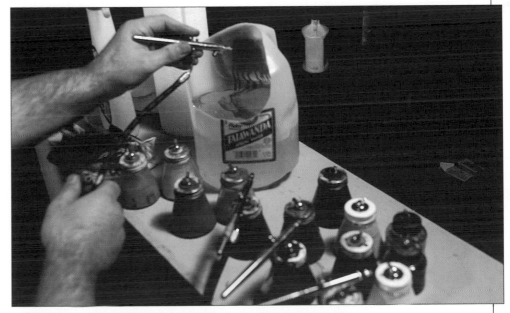

Create a water jug like this one for cleaning and unclogging your airbrush.

off the top portion of a plastic milk or water jug, leaving the handle attached.

Respirator Mask/Ventilation. Get into the habit of wearing a mask when you work. Most paints have health warnings on their labels. Acrylic fabric paint, though nontoxic, still can build up in your lungs. Also, work in a well-ventilated area.

For Commercial Illustrators Only

For some effects, such as highlights and fine detailing, you'll need to use a handbrush. If your budget allows, purchase a no. 0 or 1 sable-hair brush for detailing and a no. 5 for washes and dry-brush work. Ultimately, try to add nos. 3 and 8 to your collection.

An alternative to the sable-hair is the less expensive, more durable camel-hair brush. This brush is useful for mixing paints and filling an airbrush cup. It's most efficient to have about six camel-hair brushes in the range of nos. 4, 5 and 6 to avoid constantly cleaning one brush each time you change colors. Disposable nylon brushes, no. 0 or 000, are useful for applying liquid frisket masking. To clean dust off your board, it's good to have a dust brush handy.

For T-Shirt Artists Only

There are a few other tools that T-shirt artists need, but commercial illustrators don't.

Corkboard and Easel. A corkboard works well for mounting the T-shirt because it's absorbent and inexpensive. Alternatives are Masonite and cardboard. Put the board inside the T-shirt and wrap the loose fabric to the back of the board so the front of the shirt is taut. To help hold the shirt in place, apply spray adhesive

lightly to the board, position the shirt and press. The adhesive washes out of the shirt. You need something, such as an easel, to hold the T-shirt nearly vertical as you work. You can buy or build one at a fairly low cost.

Heat Press. A heat press sets the paint in the T-shirt. See a local T-shirt shop about using its heat press for best results; some will do it as a courtesy. As a last resort, a very hot iron is acceptable, although it will never get hot enough to permanently set the colors.

How to Clean or Unclog Your Airbrush

Dunk the brush in your water jug beyond its siphon tube, but not so far that the brass fittings in the back are submerged. Spray air to circulate water throughout the brush.

White, brown and fluorescent paints clog most frequently. Black tends to build up on the tip. Each time your brush clogs make a mental note of where the clog is. This will make future unclogging faster, since you'll be more familiar with the eccentricities of your airbrush and paints.

Try these tricks when your brush clogs:
1. Wipe the needle.
2. Increase air pressure 3 to 4 psi.

3. Pull the nozzle off and spray into the water jug.
4. Use a spray bottle to apply water directly into the brush.
5. Attach a paint jar with water in it and spray the water through the brush.
6. Run acetone (nail polish remover) through the brush if paint has dried inside. Always wear a mask when you use acetone to keep from inhaling the fumes. You won't need to rinse out the acetone, as it evaporates quickly.

Finding Ideas

Airbrush artists rely heavily on books, magazines, billboards, ads, toys, greeting cards and maps as sources of ideas and for visual reference. You can create your own references by shooting photographs of objects or people you want to render. A clip file can hold printed photographs or illustrations that you cut out of magazines, brochures and other printed materials.

Turning Your Ideas Into Sketches

Once you know what you want to draw, you can use many techniques to turn an idea into a sketch. Commercial illustrators' sketches are about two times the final reproduction size, while T-shirt artists' obviously work at the final size. The following are sketching techniques you can use:

1. Grid Technique. A grid is an excellent way of scaling an image either up or down in size. Draw a grid of squares to a specific size (for instance, 1-inch square) on thin tracing paper. Place this grid over your reference material, such as a photograph. Draw another grid to the scale you want to do your illustration. (Using the 1-inch example, if you wanted to enlarge your material

200 percent, your new grid would be composed of 2-inch squares.) Using the grid as a guide, you now have reference points to follow to enlarge or reduce your image.

2. Tracing Technique. Find a visual reference that closely matches the image you have in mind. Lay tracing paper over the visual and trace it, adjusting the image as necessary to suit your creative needs. A light table may be useful for dark images.

3. Photocopy Enlarging. The modern photocopier now lets you reduce or enlarge images. Although you can't photocopy onto your actual painting surface, you can size a reference and then make a sketch of it for transfer to frisket, acetate, stencils or painting surface.

4. Projection Technique. If you are using a slide as a visual reference, you can project that image onto tracing paper or your painting surface taped to a wall. Then simply trace the image.

Getting Your Sketches Ready to Paint

You can choose from a number of techniques for transferring your final sketch to masking, stencils or painting surface.

1. Lead Pickup Technique. This method is best suited to commercial illustrations that require hard edges. First, tape your final sketch to a flat surface. Cut a piece of frisket film large enough to cover the sketch. Remove the paper backing from the frisket and place the frisket over the drawing. Using a straightedge, lightly burnish (rub) the frisket-covered sketch; this pressure will transfer the sketch lines to the back of the frisket. Carefully remove the frisket from the sketch and place it on your painting surface. Your surface should be about two inches larger

on all sides than the sketch. Make certain the frisket rests smoothly on the board with no trapped air pockets. Lightly cut along the sketch lines using a no. 11 X-Acto knife and blade, leaving the pieces in place on the board. You should also save each piece as you spray so you can reposition it to protect the sprayed areas.

2. Color-Coded Method. An advantage of using frisket film is the option of reusing the frisket pieces to remask sprayed areas of your commercial illustration. But it can be time-consuming to reposition the pieces. One way to simplify this process is to color your drawing directly on the frisket using markers or some other frisket-adhering color. Do this before you cut the frisket. The color-coded frisket pieces are easily repositioned on your painting. Or when you remove frisket pieces from an image, position them in the matching place on your original sketch. Then you can easily relocate them for repositioning on the painting.

3. Sketch Projection. The Lucidagraph is a tool that projects a drawing or a visual reference onto your painting surface enabling you to "trace" the image directly onto the surface. You can reduce or enlarge the image as desired. Some Lucidagraphs project onto a glass plate on which you place tracing paper. The resulting sketch is transferred to your painting surface via a technique such as lead pickup.

4. Direct Sketching. If your drawing skills are decent or if you want to continue developing them, you can draw directly onto your surface. For a T-shirt use vine charcoal, which is very soft and gives you the flexibility to change or remove the drawing by merely "blowing" it off with your airbrush. To draw on illustration board,

use a no. 2 pencil and a kneaded eraser for cleanup.

5. Freehand Spraying. Some artists "draw" directly onto the painting surface with paint. Although this technique is efficient, it requires well-developed drawing skills.

6. Pouncing. This is a method used by T-shirt artists. Poke small holes along the lines of your sketch using a pointed object such as an ice pick. Place the drawing on your painting surface. Use a pounce pad—a sack made of porous material, usually cotton, that's filled with powdered graphite—and press it against the holes in your sketch. You are left with a series of graphite dots on your painting surface that you connect with vine charcoal, much like the dot-to-dot pictures children draw.

Getting Into Action

Chapters two through eleven are all action, filled with step-by-step demonstrations, tips and tricks, professional techniques, close-up views of various techniques, and galleries of professionally rendered illustrations. All of these features are designed to give you a complete education in the essentials of good airbrush skills.

If you want to re-create the projects for practice, feel free to alter them. You can use different shapes, placement of objects, colors and paint. In fact, you *should* experiment, since there are many ways to render any single illustration, and very soon you'll discover your own personal style.

Chapter 2

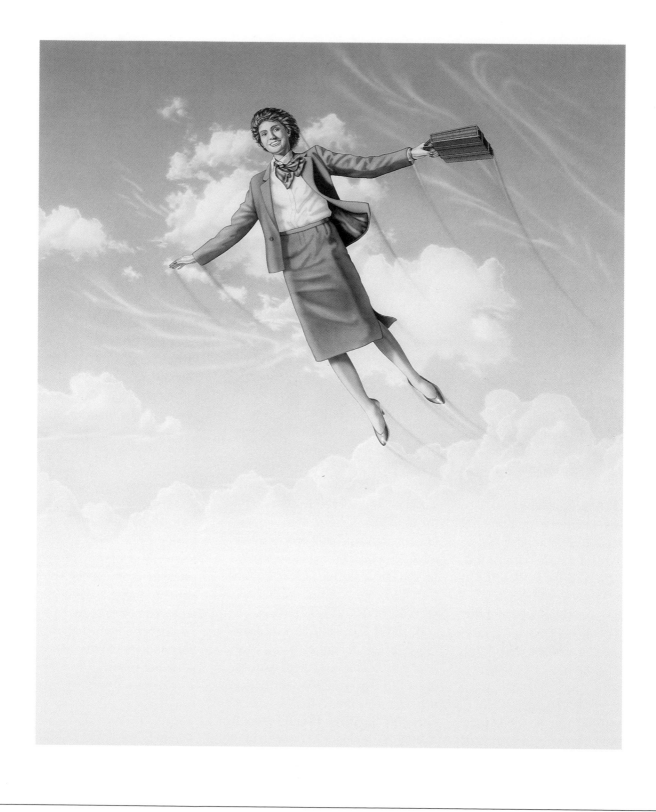

AIRBRUSHING FREEHAND

Freehand spraying is airbrushing without any masks or stencils and is used in both commercial and T-shirt art. Commercial illustration relies on freehanding to render effects that need to be soft and diffused, such as sweeping strokes of color, and other qualities you can't achieve with masks.

Professional T-shirt artists use freehanding extensively as a speed technique because it lets them produce and sell the quantity of shirts needed to turn a profit.

Mastery of the freehand technique comes when you can control the airbrush trigger that supplies air and paint, you know how close to the surface to position your brush, and you can hold and move the airbrush with a steady hand. These skills come with practice, perseverance and patience.

The projects in this chapter feature objects and lettering that have fluid lines and shapes and are ideal for rendering freehand.

FREEHAND BASICS

You control the aesthetic quality of freehanding by the way you use the airbrush. By holding the needle close to the surface and slightly pulling back on the trigger you can produce a fine hairline spray or small points of color. As you practice this technique, experiment with lower air pressures for different effects.

As you pull the brush away from the surface, lines and dots widen, and your freehanding becomes more sweeping to cover broader areas, such as backgrounds or skies.

If you freehand with your spraying surface lying flat in front of you, improve your technique by resting your "spraying" elbow on the table-top; this steadies the brush. If your surface is nearly vertical, use your free hand to support and steady the brush.

Since your freehand spraying can only be as good as your overall control of the airbrush, take every opportunity to practice spraying. Every professional airbrush illustrator began just this way, by spraying hundreds of practice lines, curlicues and squiggles; moving the brush close to or away from the surface; and experimenting with air pressure and paint amount.

No one is born a master of the airbrush. Expect to render some less-than-pretty effects: spidering, uneven line widths and irregular paint coverage are common. Practice and experimentation will eventually rid your illustration of these gremlins.

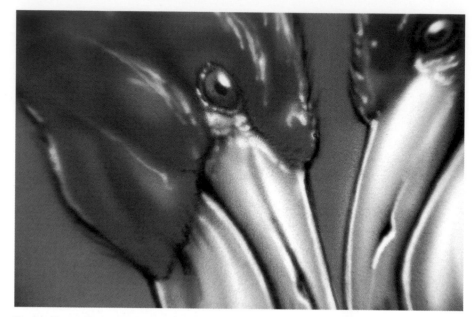

Freehand spraying can define both shape and texture.

Freehanding gives you the flexibility to render the two styles of puffy clouds shown above.

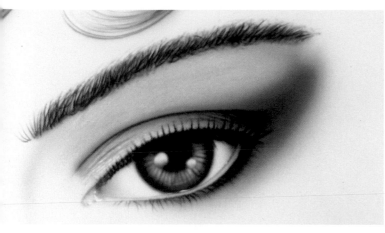

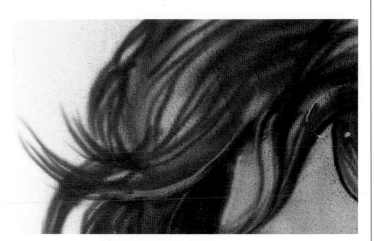

Soft eye shadows like these are unobtainable any way but through free-handing.

Hair, especially wild or windblown, is the perfect texture to render freehand.

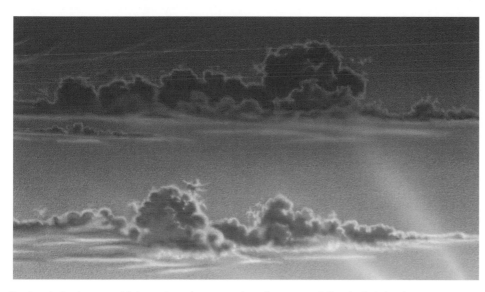

Freehanded color can add drama to an image, such as these sunset-illuminated clouds.

FLAMINGO HEART

Paint: Gouache.

Colors: Ivory black, bengal rose, golden yellow, fluorescent red, fluorescent blue, yellow, violet and white.

Masking: None. Freehand.

Surface: Cold-press board.

Plus: Non-repro blue pencil.

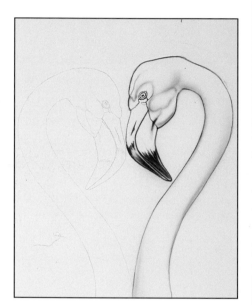

Step One

The simplicity of this illustration lets you freehand the sketch directly onto the board using a non-repro blue pencil. Using ivory black, outline the sketch freehand and darken the beak. Dilute the black paint to half-strength to render the finer lines on the face, holding the brush about one-quarter inch from the board. Position the brush one to two inches away to create broader lines and add shading and form to the face. Repeat for the second bird.

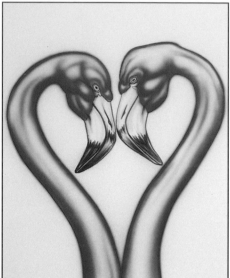

Step Two

Continue adding form and shading by using the same spray technique from Step One, this time using bengal rose and golden yellow.

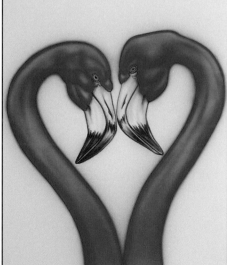

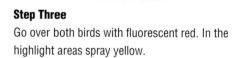

Step Three

Go over both birds with fluorescent red. In the highlight areas spray yellow.

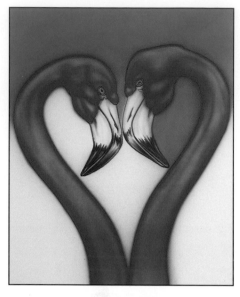

Step Four

Add exciting contrast by spraying fluorescent blue on the background. Make sure you work close to the board. Starting around the birds' bodies, hold the brush about one-half inch from the board to minimize overspray; work away from the birds. As you move more into the background, you can lift the brush to create a wider spraying pattern and gain more control over the tonal coverage.

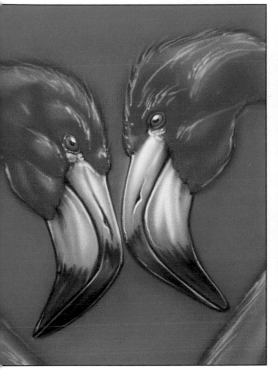

Step Five

Add more overtones to the birds by spraying violet to deepen existing shadows and white to pull out highlights. Notice that the violet overspray adds a pink tint to the beaks. Add white highlight dots to the eyes. Go back over the darkest shadow lines with black to sharpen them. Remember to hold the brush farther away from the board to spray diffused areas, such as shadows, and closer to the board to spray fine-line details, such as feathers.

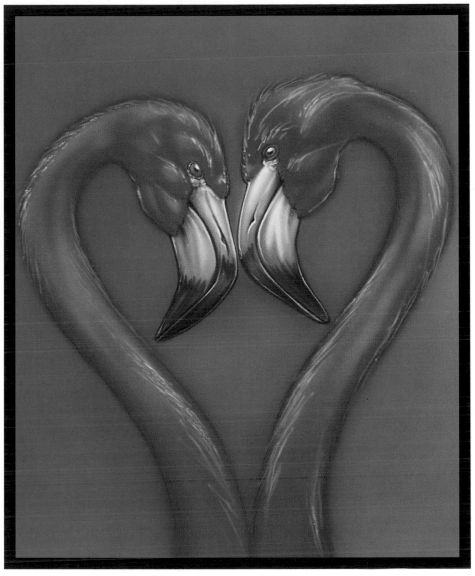

Step Six

After you have finished both birds, spray the illustration with fixative to protect the fluorescent paints. Handle this illustration with care even after you've protected it.

HOT & SPICY

Paint: Acrylic Fabric Paint.
Colors: Black, yellow, red, green, orange, blue and white.
Masking: None. Freehand.
Surface: T-shirt.
Plus: Vine charcoal or soft-lead pencil.

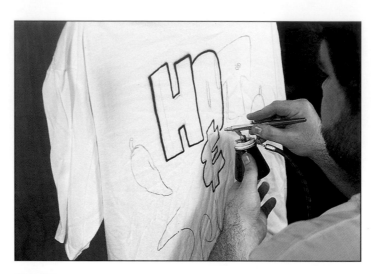

Step One

Draw a square on the T-shirt using vine charcoal or a soft-lead pencil. Inside this box write "HOT"; overlap the "O" with an ampersand, and add the word "Spicy" and the two hot peppers. Hold the brush one-eighth to one-quarter inch from the shirt and outline the drawing in black. Blow off any loose charcoal.

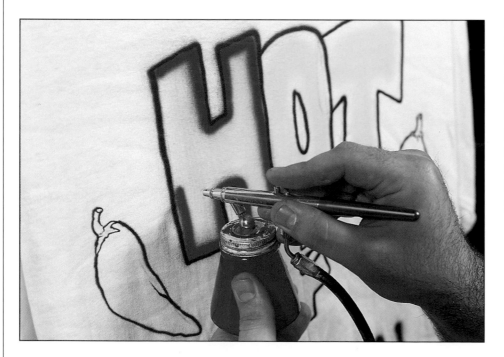

Step Two

Fill in the "HOT" letters with yellow, working from the center outward. When freehand spraying on a vertical surface, make sure you support the brush with your free hand. Don't spray the yellow right up to the outline since you'll cover this area with red paint. Apply the red inside the black outline; fade the color toward the center by holding the brush three inches from the shirt and letting up on the air pressure.

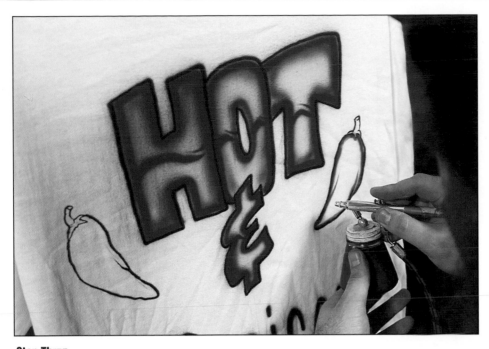

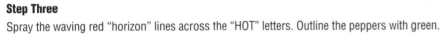

Step Three
Spray the waving red "horizon" lines across the "HOT" letters. Outline the peppers with green.

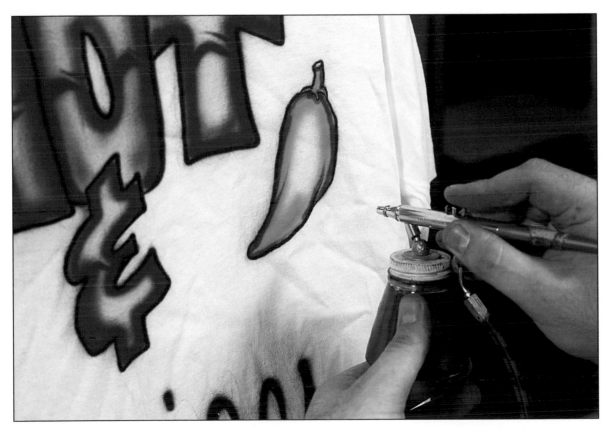

Step Four
Fill in the peppers with green, fading toward the center to give them shape. Add the black creases in the peppers.

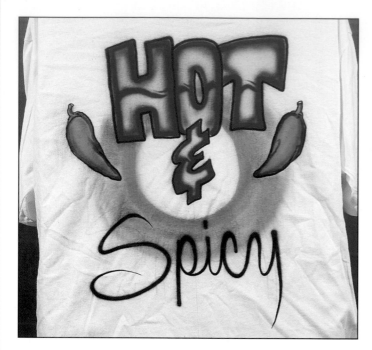

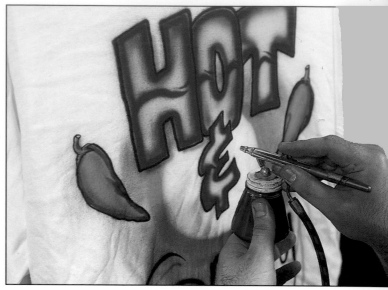

Step Six

Add the blue drop shadow.

Step Five

Spray yellow lightly over the green to create a new color. Add the orange circle, holding the brush four inches from the surface. You can spray over the black lettering, but not over the peppers or "HOT" since the orange will change those colors.

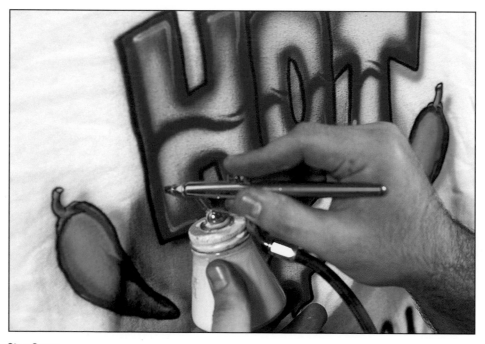

Step Seven

Add the white highlights to the letters. Repeat, if necessary, to intensify them.

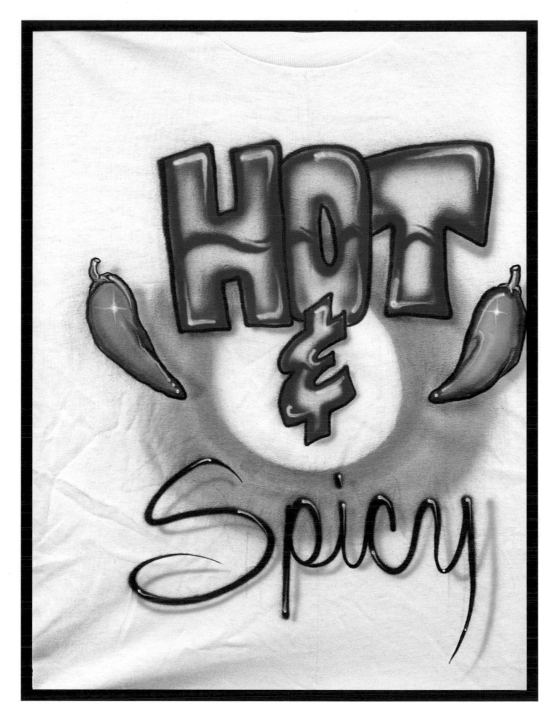

Step Eight
Add shiny white starbursts to the peppers by spraying very white center points and fading the color out.

PROFESSIONAL PORTFOLIO

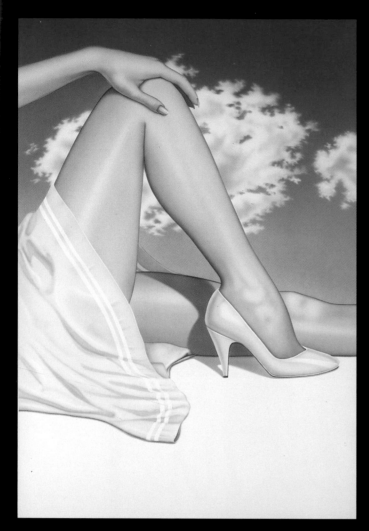

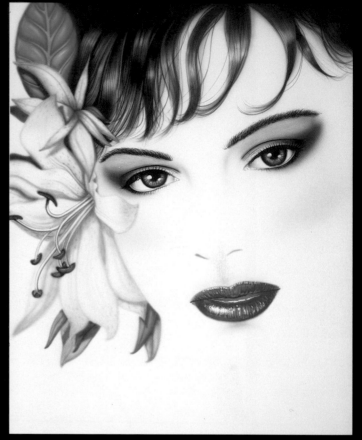

Freehanding was used extensively to render this image because masking would have created a hard-edged quality, which would be unsuitable for the legs, dress or sky.
Artist: Jim Effler

Freehanding produces just the right mood for some subjects, and this dreamy portrait is a perfect example. Notice how the edge quality of the flowers is even softer than those of the woman. This serves to make the flowers recede to the background so they look like they are tucked into her hair. The soft eye shadows or wispy bangs would not have been attainable using masks.
Artist: Jim Effler

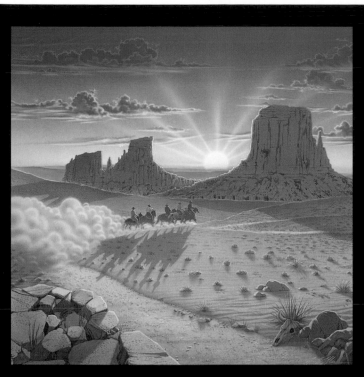

This compact disc artwork uses freehanding extensively, for the clouds, the mesa textures, the dust clouds and the sand.
Artist: Jim Effler

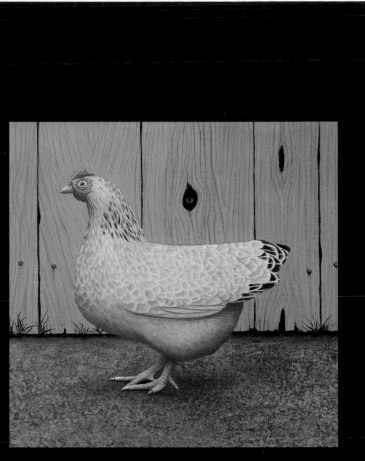

In this illustration freehanding was used to render the chicken's feathers. Notice the other textures—the bird's face (handbrush), the wood (pastels) and the ground (sponging).
Artist: Joe Taylor

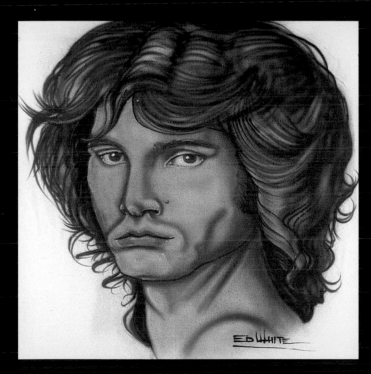

Freehanding in this T-shirt art lets the artist render the crownlike mass of hair that characterizes the late Jim Morrison.
Artist: Ed White

Chapter 3

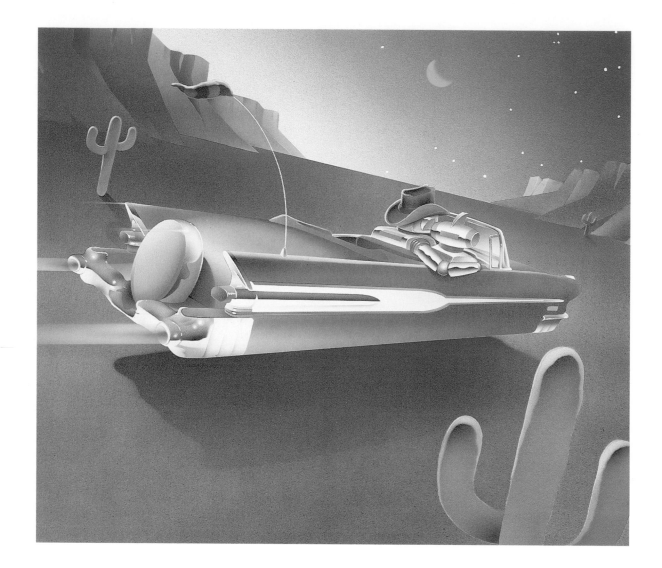

GRADATING COLOR

The airbrush is the perfect tool for creating a gradated effect that begins as a solid color and fades to white (or fades into an adjacent color). Commercial and T-shirt artists alike use the gradation technique to render backgrounds, skies and sunsets; to give not just color but shape to objects; and to create a sense of distance, such as from foreground to horizon.

Gradating a color successfully requires a steady trigger finger for consistent air pressure and paint flow, and a steady hand for consistent spraying and color coverage. The same advice holds true here as throughout this book: practice equals mastery.

The two projects in this chapter show how to use gradated color to add drama to a landscape scene and form to a flower.

GRADATION BASICS

While application of the gradation technique is broad, the technique itself is the same, whether applied to a sweeping expanse of blue sky or a delicate, pink rose petal.

To spray a gradated area, hold the airbrush about four inches from the surface and start to spray from right to left and back. Keep your stroke steady and rhythmic. Overlap and evenly space each stroke. Work toward the area of the illustration that is to remain white. Repeat this process to fill the area. As you progress along the gradation area, reduce the paint supply with each pass by easing off the trigger. As you near the last one-third of the area, lift the brush higher to reduce the spray coverage. The first half of this final one-third should be colored only by overspray, and the last half should be left white.

Gradation can be understated yet still strongly define a shape.

Highlights often include a gradation of reflecting color.

Sky gradation can apply color to objects such as the moon or stars.

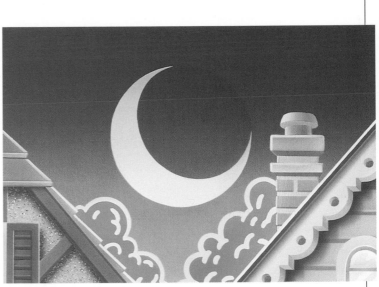

Sky gradation can be used as a backdrop to a moon or stars.

Gradation in this lettering shadows curves along the foreground surface.

PAINTED DESERT SCENE

Paint: Acrylic fabric paint.

Colors: Black, green, yellow, orange, red, purple, blue, brown and white.

Masking: None. Freehand.

Surface: T-shirt.

Plus: Vine charcoal

Techniques: Airbrushing Freehand, pp. 8-19

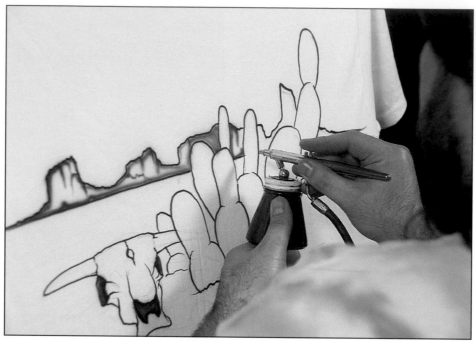

Step One

Freehand sketch your base drawing with vine charcoal, and outline it with black paint. Note the jagged, irregular lines that are created by shaking the brush slightly. Blacken inside the outlined areas. Hold the brush two inches from the T-shirt to create the diffused spray for the background hills. Mist the shaded sides of the cacti and skull.

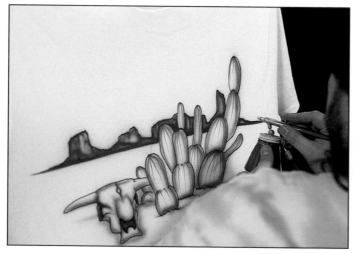

Step Two

Give shape and texture to the cacti by outlining them with green inside the black lines. Taper the ends of the short vertical lines by lessening the air pressure.

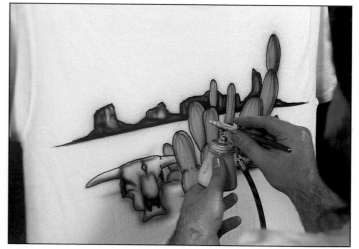

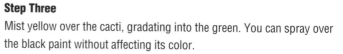

Step Three

Mist yellow over the cacti, gradating into the green. You can spray over the black paint without affecting its color.

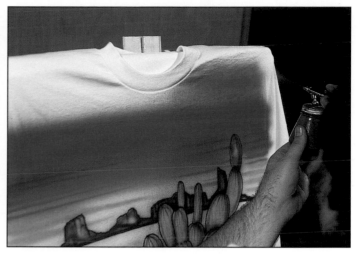

Step Four

Spray yellow above and below the hills across the horizon. Start at the top edge of the yellow and spray orange, gradating into the yellow to blend the colors. Spray tapered orange lines into the yellow to create the effect of clouds reflecting the sunset.

Step Five

Spray red, purple and blue using the same gradating technique in Step Four.

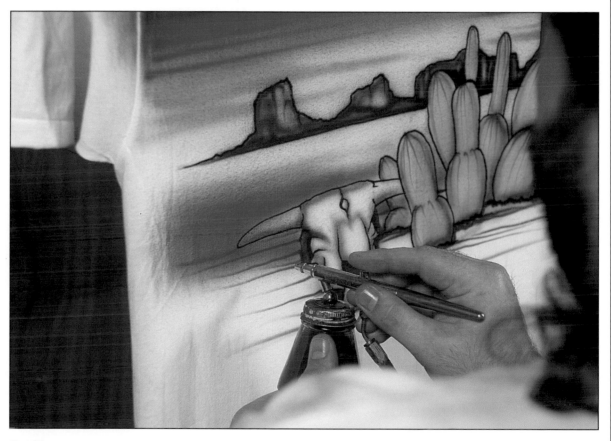

Step Six

Spray orange and red paint to create the effect of sand reflecting light; use the sky-spraying technique. Spray brown tapered lines across the sand.

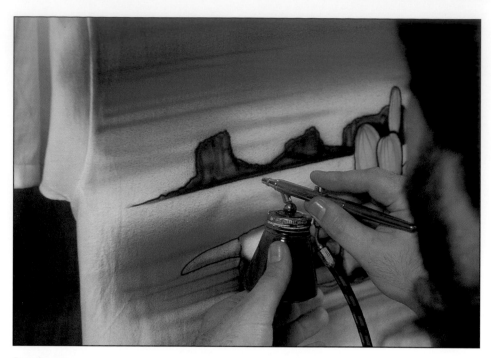

Step Seven

Add brown to the hills, cactus shadows, skull and just beneath the hills.

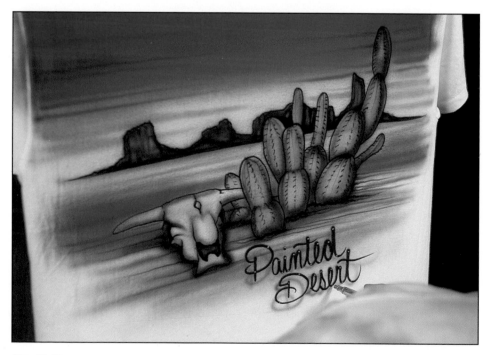

Step Eight

Paint the black script lettering and drop shadow. Remember to hold the brush about one-and-a-half inches away to diffuse the shadow. Add the short black texture lines to the cacti. Mist black shading around the skull and inside the cacti.

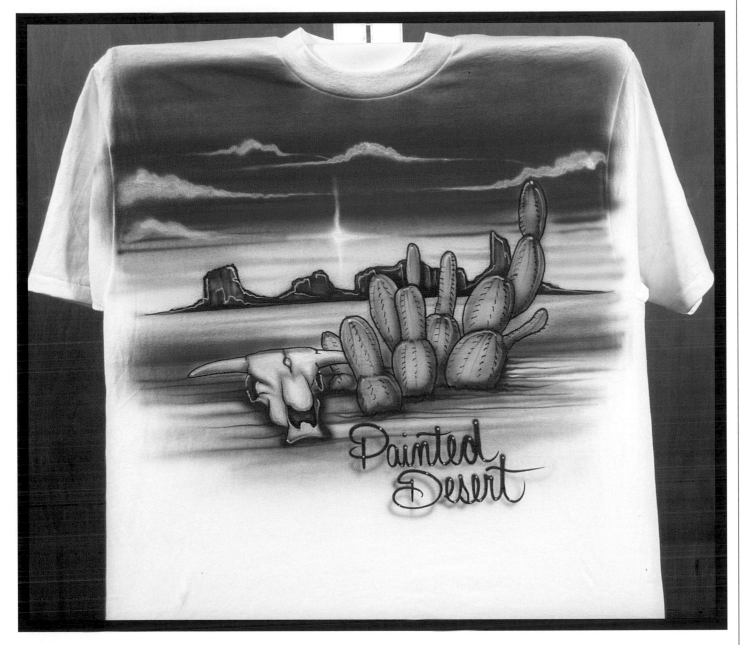

Step Nine

Spray white highlights on the skull, cacti and hills, and spray in the irregular clouds. Add white dots to the lettering to enhance the roundness of the letterforms. As a last step, add the white radiating sun using the starbrust technique described on page 17.

RED ROSE

Paint: Gouache.
Colors: Deep violet, white, warm flame red,
Winsor red, violet, ultramarine blue, permanent
green light and permanent green middle.
Masking: Frisket film and 3mm clear acetate.
Surface: Cold-press board.
Plus: Non-repro blue pencil.
Techniques: Airbrushing Freehand, pp. 8-19,
and Using Masks, pp. 32-43.

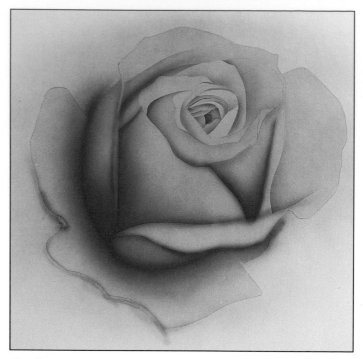

Step Two
Repeat the application of the shadow areas, this time freehand spraying
Winsor red for a softer edge.

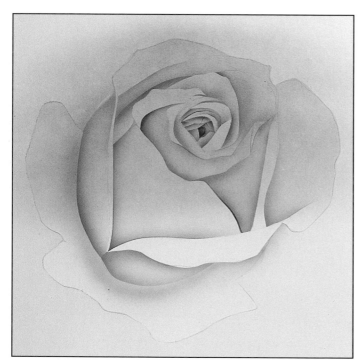

Step One
Draw a simple contour line sketch directly on the board using a non-
repro blue pencil. Cover the sketch with frisket and cut along all pencil
lines. To render the base shadows, remove the frisket from the bottom-
most petal and spray a light layer of deep violet along the bottom edge,
gradating the color away from the edge. Reposition the frisket and move
on to the other petals. Spray a light layer of warm flame red over the
entire rose to create the middle tone.

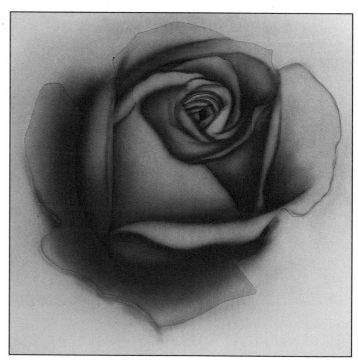

Step Three
Carefully study the illustration and locate the very subtle violet shadows
around the center of the flower. Create these by spraying violet through
acetate masks that were cut to add contrast and definition to the shadow
areas.

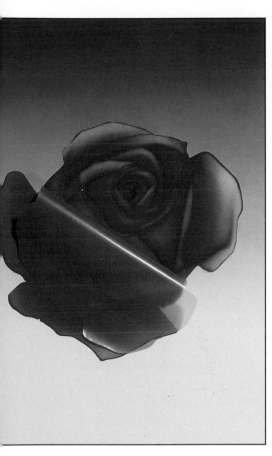

Step Four

Cut new masking to cover the entire flower surface and gradate the background using ultramarine blue from the top of the board to the bottom. Note how the color is dark at the top and nearly white at the bottom.

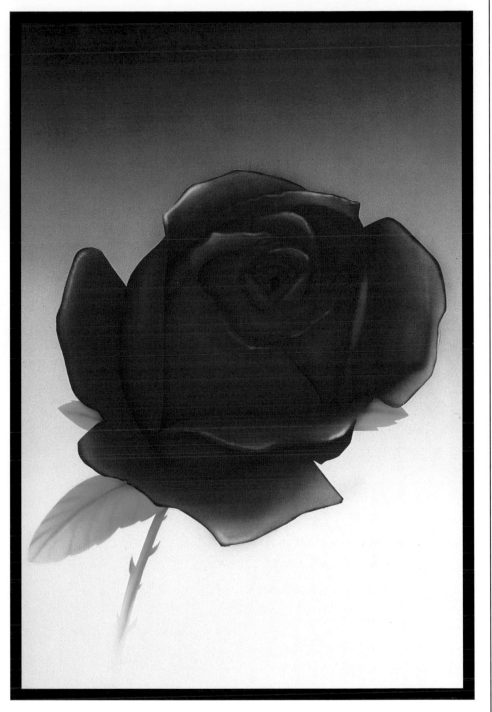

Step Five

Add the stem and leaves using loose acetate masking held in position. Spray permanent green light for the base color, fading the color out at the leaves' tips and stem bottom. Freehand the fine-line highlights with white and the leaf veins with permanent green middle.

PROFESSIONAL PORTFOLIO

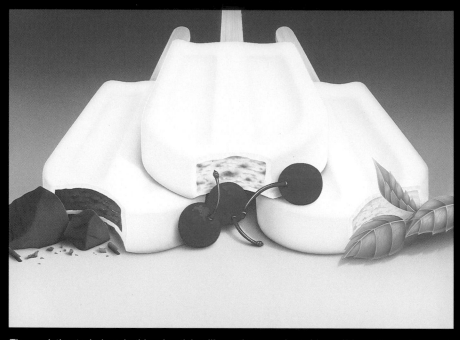

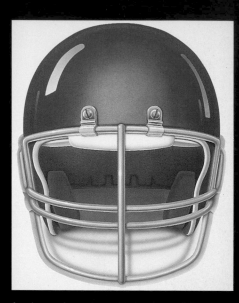

The gradation technique in this advertising illustration sets the subject off from the background, focusing the viewer's attention on the product. It also adds the subtle but classic molded look to the white chocolate coating.
Artist: Toby Lay

As shown throughout this book, gradation is used to render shiny painted surfaces. But equally important in this football helmet is the need to indicate the roundness of the helmet. Imagine the object with flat, rather than gradated, color. It would look unrealistic and much less appealing.
Artist: Jim Effler

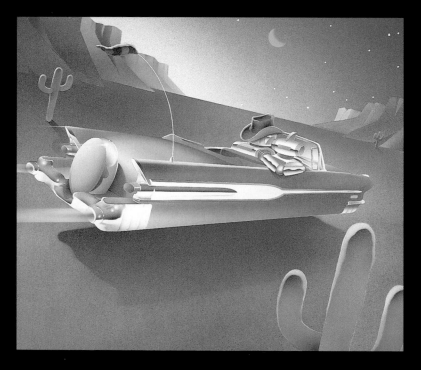

Gradation is a technique to use when you want to show distance, such as in this landscape portfolio piece. Notice how the artist uses gradation to show the transition in the sky between the setting sun and the darkening, star-filled areas.
Artist: Jack Whitney

Book covers need space in which to position the book title or, in this case, the author's name. The ultra-darkness of the top area of the gradation also increases the overall contrast of the piece, dramatizing the lettering.
Artist: Jim Effler

As you've seen in other illustrations in this book, gradations can be sprayed with a single color or with multiple colors. Notice how the gradation in this T-shirt art has additional visual interest by the inclusion of stars, clouds and a sun flare.
Artist: Ed White

The gradation in this billboard artwork has two purposes: to illustrate the night sky and to give the advertiser an area in which to position the advertising copy.
Artist: Jim Effler

Chapter 4

USING MASKS

Masks—called stencils for T-shirt work—are key tools for airbrush illustration. You design them to be either "positive" (expose areas to spray) or "negative" (protect areas from spray).

Ultimately, masks and stencils let you produce different edge effects, as discussed on the next two pages; spray shapes and patterns; render highlights, shadows and dimension; and create the feeling of movement.

Most artists produce their own masks or stencils, although some purchase precut ones, especially for T-shirt lettering. Eventually, so you can enjoy the most creative options, strive to design and produce your own masks and stencils.

The projects in this chapter show how to use frisket film alone and in combination with acetate.

MASKING BASICS

You must understand the capabilities of the different masking materials before you can choose the best one for your illustration.

Commercial illustrators usually use adhesive-backed frisket film and clear 35mm acetate for masking. T-shirt artists design stencils from cardboard, vinyl, polystyrene or pellon. But almost any found object, such as a piece of lace or screen, can be used.

Masking for Commercial Art

The major difference between frisket film and acetate is the edge quality you get in your illustration. Frisket film gives you the cleanest edge possible because it adheres to the board and prevents underspray—that is, paint getting beneath the mask where you don't want it. Although frisket can be placed on a painted portion of your illustration, it shouldn't stay there longer than two days because it might pull up some of the paint. Spray some test areas, covering the paints with frisket for varying time periods, and then remove the frisket to determine the best timing for each paint and surface combination.

Acetate is the better choice if you are masking an area that already has a layer of paint on it; the acetate won't pull the paint up. Acetate is flexible in terms of the edge qualities you can produce. To create a hard edge, coat an acetate mask lightly with spray adhesive and lay it flat on the board. (Spray adhesive also can pull up paint, so again, spray test areas first.) Some adhesive may stick to the surface; clean it off using a soft rag and rubber cement solvent.

To create a softer edge, position the acetate mask above the surface by resting it on something such as a quarter or a small, rolled-up piece of low-tack artist's tape. For even softer edges, hand-hold the acetate on the surface and actually move it slightly back and forth.

To cut frisket film or acetate use a no. 11 X-Acto knife and blade, or something similar. Cut lightly. You only want to "score" the material; the pieces will then snap apart.

Liquid frisket, applied using a nylon handbrush, is another masking option. It's useful for special applications such as rendering textures and masking small objects or areas. When dry, liquid frisket is rubberlike, waterproof and impervious to paint. Remove liquid frisket with low-tack tape.

Transpaseal, which is usually used for laminating, has an adhesive backing that is too aggressive for use on boards. However, it is effective for photo retouching projects, such as the one on pages 110-117, because of the way it resists liquid bleach.

You may eventually want to consider buying a stencil burner, which "cuts" acetate or frisket stencils and masks with heat. Its sharp tip produces small holes and irregular shapes more easily than a knife blade.

Stenciling Facts

Cardboard is popular with beginners because of its availability and low cost. Its stiffness makes it easy to handle and reuse. French curves are useful guides for cutting stencils.

Polystyrene is very durable and long-lasting. If paint builds up on it, you can just peel it right off.

Heavyweight pellon is a good, multifaceted material that absorbs paints, preventing buildup on the mask. Available from airbrush supply houses, and sometimes from screen printing companies, it is durable and long-lasting. Avoid the lightweight pellon used in sewing.

A no. 11 X-Acto knife is the tool for cardboard or polystyrene. Sharp fabric scissors cut easily through pellon.

To adhere a stencil to a T-shirt, spray the stencil lightly with adhesive. This one application probably is all you'll need, even if you reuse the stencil.

Hard-edged shapes are sprayed through an acetate mask to render this green glass bottle.

Liquid frisket is applied with a nylon handbrush, sprayed with color and removed using white artist's tape to produce frothy waves.

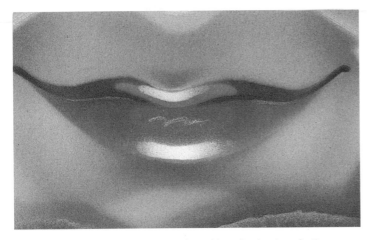

Acetate masking is necessary to produce this soft-edged, perfectly proportioned and realistic mouth.

Soft-edged acetate masks are combined with gradation to render soft fabric folds.

Acetate durability lets you cut one mask and simply move it across your image to render a repetitive shape.

PRETTY WOMAN

Paint: Gouache.

Colors: Burnt sienna, black, spectrum violet, white, golden yellow, warm red and ultramarine blue.

Masking: 3 mm acetate and frisket film.

Surface: Cold-press board.

Plus: No. 0 or 00 handbrush, kneadable eraser, typing eraser.

Technique: Airbrushing Freehand, pp. 8-19, and Gradating Color, pp. 20-31.

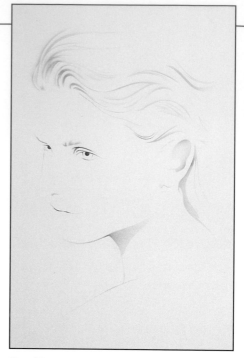

Step Three

This step shows the very soft areas of line and tone created in Step Two.

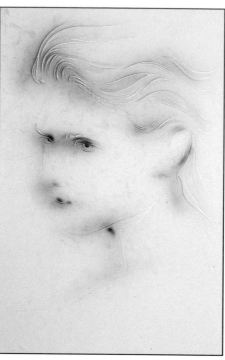

Step Two

Lay a large piece of acetate over the entire drawing and gently cut and expose openings for the darkest shadow areas. Mist burnt sienna and black lightly over areas of the hair as shown. Expose the brows, eyelines, nose, ears, mouth and neck areas, as shown. Mist spectrum violet and black. As you spray, hold the mask in place, moving it slightly to soften the edges.

Step One

This step shows the tracing paper original sketch over which acetate masks will be cut. The drawing was not transferred to the board because the pencil lines would have shown through the color.

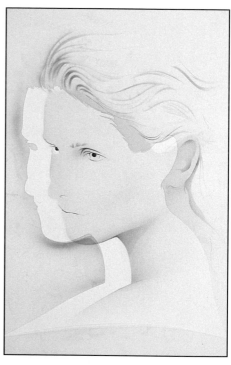

Step Four

Mask the eyes with small pieces of frisket film and cut an acetate mask to expose the entire flesh area. Spray a light layer of burnt sienna, darkening this tint in the shadows.

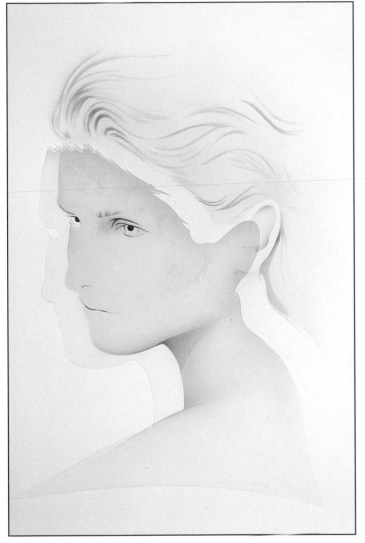

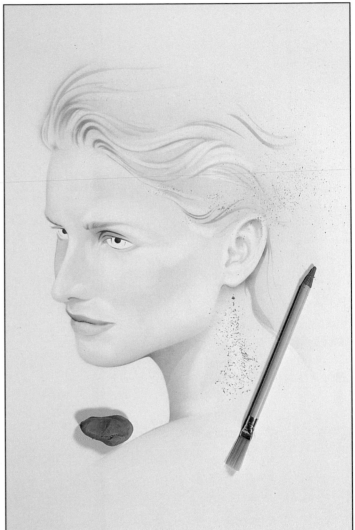

Step Five

Cover the face with the face-shaped piece of acetate from Step Four.
Spray a light layer of golden yellow over the hair, gradating the color into
the background.

Step Six

Use a kneadable eraser to create highlights and softer edges by removing
color from the face. Use a typing eraser for small highlights and hard
edges. Repeat this process of spraying layers of burnt sienna and of era-
sure until you have given the flesh tone realistic depth. Cut acetate masks
to expose the lips, eyes and eyebrows, and hold them loosely on the
board. Spray repeated light layers of warm red over the lips, ultramarine
blue over the eyes, and burnt sienna over the eyebrows; let the colors dry
between layers. Freehand spray soft, dark shadow areas with colors of
your choice.

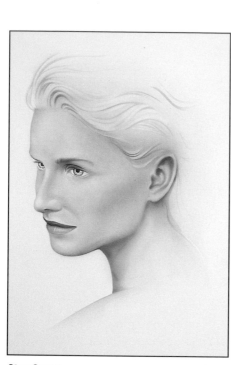

Step Seven

Continue to refine the highlights with the erasers as needed by repeating Step Six.

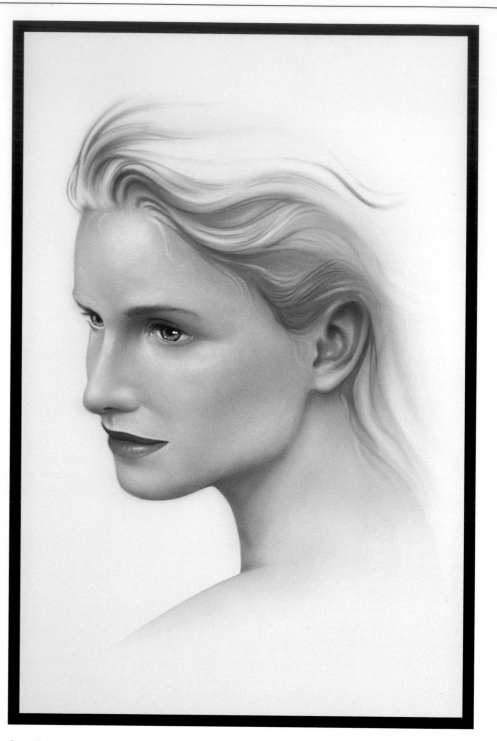

Step Eight

Freehand the darks in the hair using burnt sienna, black and the acetate mask from Step Two. Spray black over the ultramarine blue to darken and soften the iris. Add the finishing touches by handbrushing white highlights to the eyes with a no. 0 or no. 00 brush.

JET SKIER

Paint: Gouache.

Colors: Lamp black, burnt sienna, azure blue, brilliant green, fluorescent magenta, fluorescent blue, fluorescent green, purple and permanent white.

Masking: Frisket film and 3mm acetate.

Surface: Cold-press board.

Plus: no. 00 sable brush.

Techniques: Airbrushing Freehand, pp. 8-19, and Gradating Color, pp. 20-31.

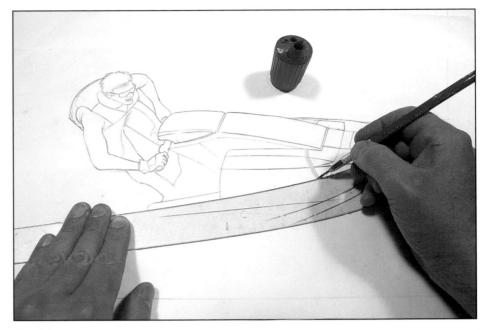

Step One

Begin with a simple pencil sketch. Notice how this sketch lacks the splashing water and motion lines that will be added freehand.

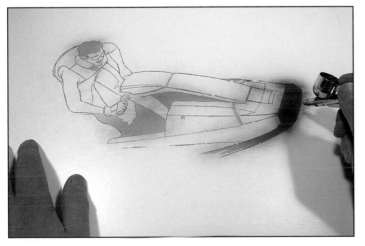

Step Two

Transfer your drawing using a method such as the lead pickup technique described in chapter one. Cut and remove the frisket from the darkest areas of the image. Spray smooth layers of lamp black.

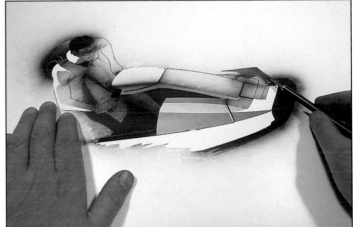

Step Three

Continue as in Step Two, spraying over those areas each time you expose and spray the lighter shadow areas. Always build your shadows from dark to light and position them to match the direction of the light. The jagged edge at the waterline is cut from the frisket and will be softened by freehand overspray later.

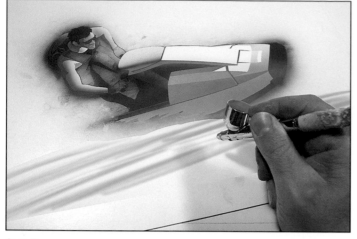

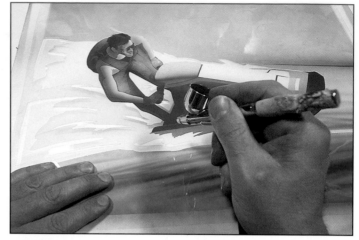

Step Four

Spray a light layer of burnt sienna over the darkest shadows on the flesh, and azure blue over the darkest shadows on the ski. Now that you've established these shapes, freehand spray brilliant green and azure blue in sweeping passes to create the effect of moving water. Blend these colors slightly to create soft edges.

Step Five

Cut acetate masks to protect the figure and the ski from overspray. Spray the sky a light layer of azure blue. In acetate, cut openings for the blue water splashing behind the skier and spray another layer of azure blue, moving the mask slightly to soften the edges and enhance the motion feeling.

Step Six

Before spraying the fluorescent magenta, yellow and green colors, position acetate masks to expose only these areas.

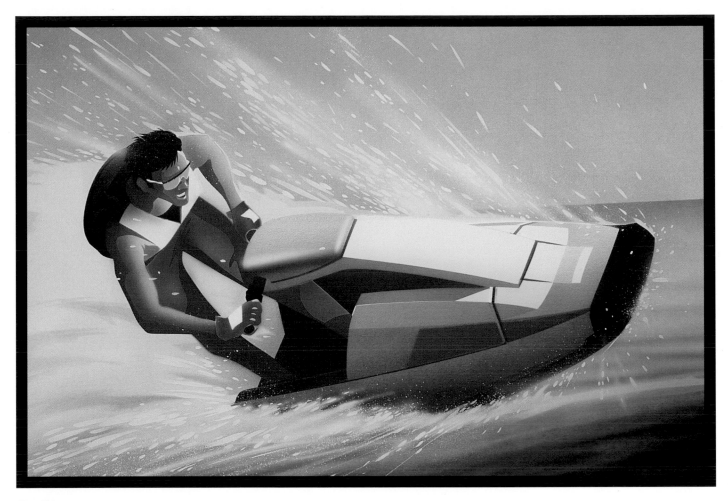

Step Seven

Enhance the deepest shadows throughout the piece by reusing the acetate masks from earlier steps within the exposed areas, freehanding purple. Intensify white highlight areas and add water splashes using a handbrush. Soften the splashes by freehand spraying permanent white in selected areas.

PROFESSIONAL PORTFOLIO

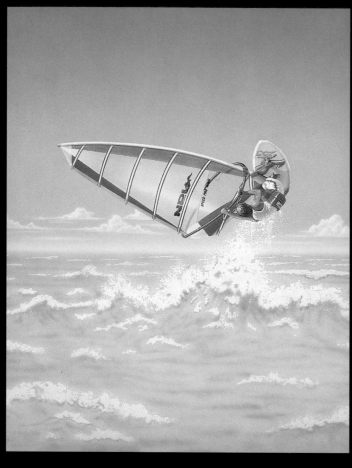

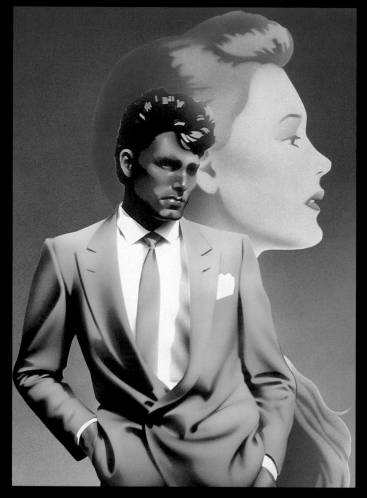

In this advertising illustration hard-edged frisket masking was used to sharply define the sailboard; liquid frisket created the foamy areas of the water.
Artist: Jim Effler

Masking is necessary to successfully superimpose two images. Soft-edged masking technique was used to render the ultrasoft edges of the figures and faces. Acetate masking was used to create the fairly soft-edged quality in the male figure. Notice how these edges appear harder than in the background figure because they are more darkly toned.
Artist: Jack Whitney

To airbrush the layers of color in this magazine ad, the artist covered the entire image with frisket film and exposed and sprayed each layer separately. This is the only way to ensure clean color and crisp edges.
Artist: David Miller

Hard-edged frisket masking gives this marketing illustration its stylized, playful quality. It also emphasizes the quality of the light and the mischievousness in the child's face.
Artist: Jack Whitney

To achieve consistency in a rendering such as this magazine ad, cut one mask for the element that will be repeated. Position the mask, spray your color and move the mask to the next spot. Repeat this technique across the whole illustration.
Artist: David Miller

Chapter 5

CREATING EDGE EFFECTS

Edge quality is the most distinctive characteristic of airbrush illustration and is the key to rendering photorealistic, stylized or ultra-soft illustrations.

Since illustration board and T-shirt surfaces produce individually unique edge qualities, familiarize yourself with them before undertaking a major project on one of these surfaces.

To determine whether an edge should be hard or soft requires visual knowledge of the object you're rendering and of the illustration style you desire. Once you have this, it's fairly academic to choose the right technique—freehanding or some type of masking—that will give you the result you want.

The two step-by-step projects in this chapter are designed to show you how to create supersharp, soft and diffused edges in a commercial illustration, and hard and soft edges in T-shirt art.

EDGE BASICS

It's a simple fact about edges: You control the quality of an airbrushed edge by whether or not you use a mask. As a commercial illustrator you'll use masking extensively to render a range of edges, from ultra-hard to soft. It's because of this range of edge effects that you're able to create the classic photorealistic styling for which commercial airbrush illustration is best known.

You may, however, be attracted to the more graphic, stylized illustration that is very popular today; this is rendered by the extensive use of hard edges.

Extremely soft edges are rendered freehand, sans masking, and are seen often on T-shirt art or combined with hard edges in commercial work.

If you do T-shirt art, you'll use masks, or what the T-shirt industry calls "stencils," more as painting guides than to render particular edge qualities. The surface quality of the T-shirt simply can't hold a hard edge like illustration board can. Most T-shirt work is done by freehand spraying—without stencils. Because of this, T-shirt art generally features softer edges and, so, a less crisp look.

For more information about masks and stencils see chapter four.

Clouds' soft edges are usually rendered freehand.

Human faces show soft edges in the nose and harder edges in the lips.

Gradated color can produce a gradated edge quality that moves from hard to soft, such as in the eye's iris.

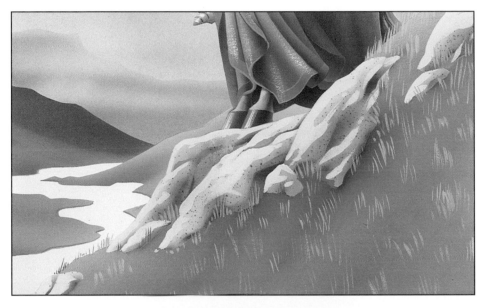

An edge can be irregular, such as those in these stones, to depict the character of an organic object.

White highlights are useful for defining edges while at the same time creating a reflective surface.

ROMANTIC WALK ON THE BEACH

Paint: Gouache.

Colors: Flame red, golden yellow, yellow primrose, peacock blue, ultramarine blue deep, burnt sienna, black, permanent green middle, ivory black and spectrum purple.

Masking: 3mm clear acetate.

Surface: Cold-press board.

Plus: Spray adhesive.

Techniques: Airbrushing Freehand, pp. 8-19; Gradating Color, pp. 20-31; and Using Masks, pp. 32-43.

Step One

Transfer your drawing to illustration board using one of the transfer techniques described in chapter one. Cut a piece of 3mm acetate big enough to cover the sky. Out of this acetate cut a circular mask to cover the sun only; hold this mask in position on the board with a very light coat of spray adhesive.

Step Two

Freehand spray the sky from the top down gradating flame red, golden yellow and yellow primrose. Hold the brush one inch from the surface to render the ultrasoft, diffused edges between colors.

48

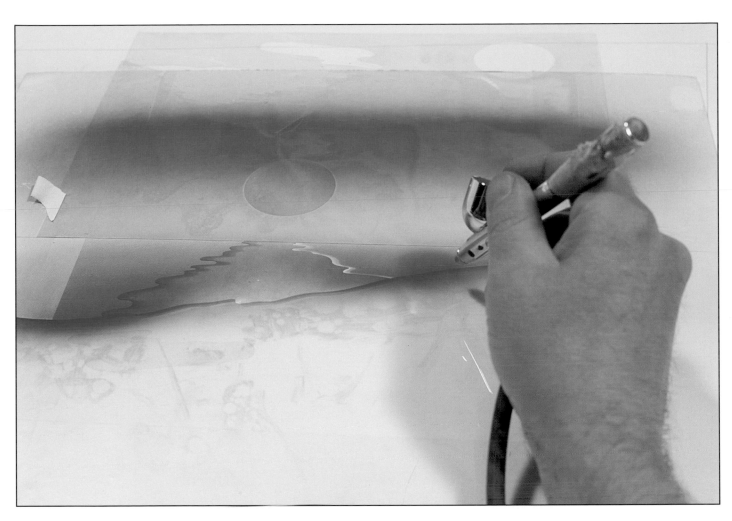

Step Three

After the sky is dry, cover it with the acetate mask from which you cut the sun mask. Mask the large water highlight area with acetate and the adhesive technique. Hold a curvy, uneven piece of acetate along the shoreline and spray ultramarine blue deep along the edge of the mask. Gradate the color toward the horizon to soften the top edge. Gradate peacock blue into the ultramarine.

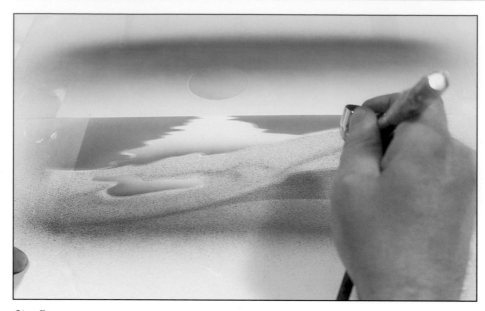

Step Four

Remask the water and uncover the large highlight area. Spray the sun's reflecting colors in the highlight using the same colors as in the sky. Reposition the acetate slightly with each spray to soften the edges. Remask the highlights once they are dry. Cut some acetate masks for the different sand shapes and hand-hold them on the board. To create the stipple effect of the sand, set your air source at 8 to 10 psi. Spray thick amounts of golden yellow, burnt sienna and black, in that order. Reposition the sand's highlight about one-quarter inch to stipple and soften its edges.

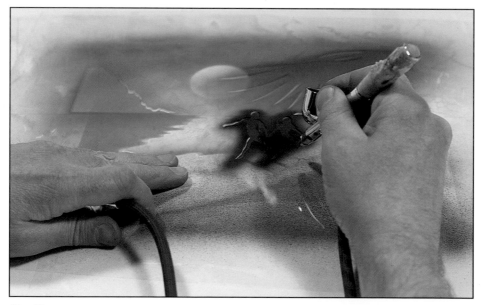

Step Five

Cover the entire image with acetate and cut openings in it exposing the palm leaves and background islands. Spray permanent green middle through the opening while moving the acetate slightly to create soft edges. Cut masks to expose the figures and the shadows on the palm leaves and the island. Hand-hold the masks and spray hard ivory black edges.

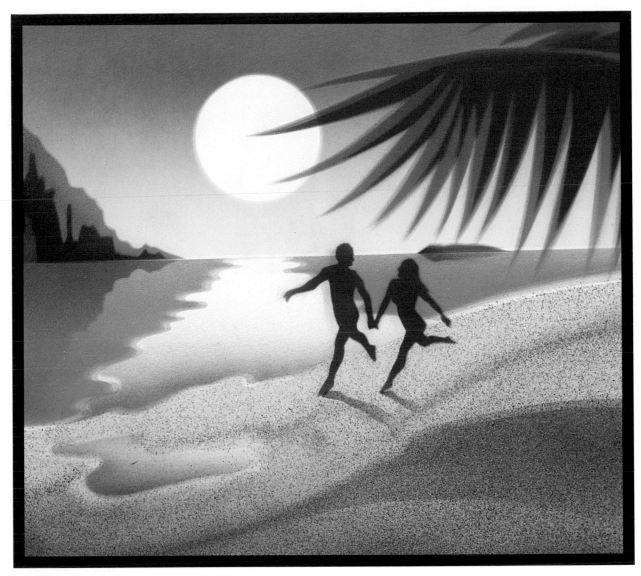

Step Six

Cut mask openings to match the purple reflection shapes beneath the islands and spray these hard-edged areas spectrum purple, holding the mask firmly in place.

TROPICAL PARROT

Paint: Acrylic fabric paint.

Colors: Black, yellow, royal blue, dark blue, orange and white.

Masking: None. Freehand.

Surface: T-shirt.

Techniques: Airbrushing Freehand, pp. 8-19.

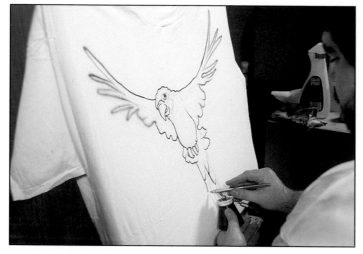

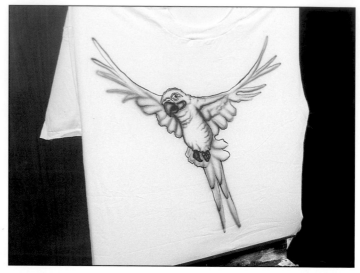

Step Two

Add black tone to the eye, beak and feet. Leave the centers of the beak and feet lighter to give them form. Continue defining the parrot's form by adding lines and shadows to its body. If you used vine charcoal to create your drawing, blow away any unnecessary charcoal lines with your brush using only air pressure.

Step One

Outline the base drawing with black paint, holding the brush one-quarter inch from the T-shirt. Create the hard, jagged edges by shaking the brush slightly as you spray. By holding the airbrush one inch or more from the T-shirt, you will achieve a soft edge along the outer wing.

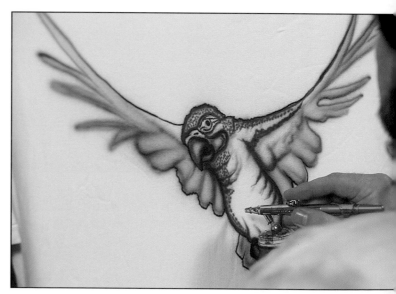

Step Three

Start at the tail feathers and spray yellow into feather areas as shown. Use royal blue to outline the bird's left wing, head, face and chest. Spray softer edges along the wing tips. Create texture by adding dark blue dots by holding the brush one-quarter inch from the T-shirt and spraying very quickly. Add royal blue lines along the black lines on the body.

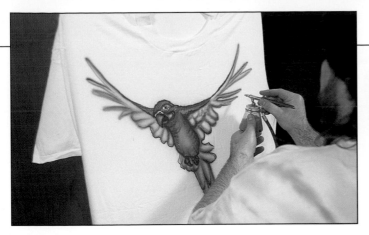

Step Four

Spray the entire body and the shoulder areas with royal blue. Overspray shadow areas of the yellow feathers with orange, holding the brush two inches from the surface. (You may use another color here if you choose.)

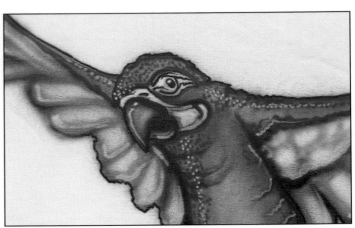

Step Five

Add white dot and line highlights on the bird as shown. You can add more interest with smaller-sized, sharper dots by holding the brush one-eighth inch from the shirt. Mist white beneath the shoulder.

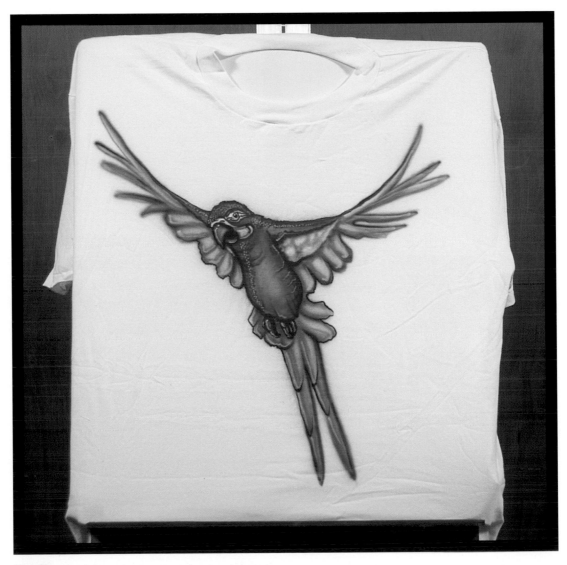

Step Six

Heat-set the shirt by ironing it or running it through the dryer.

PROFESSIONAL PORTFOLIO

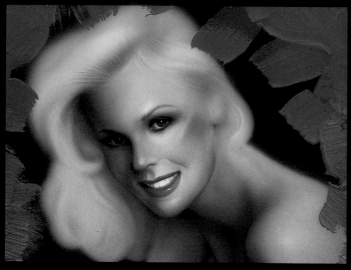

In this portfolio piece the artist uses ultrasoft edges to give the woman a sexy, feminine image. The harder, more textural edges of paint brush-strokes add contrast and visual interest.
Artist: David Miller

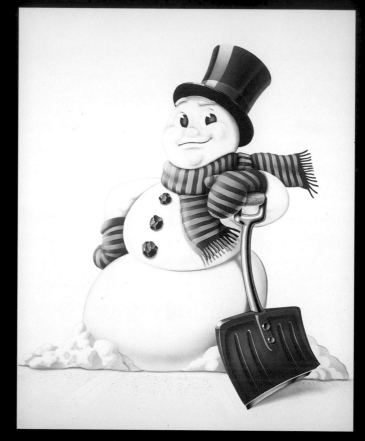

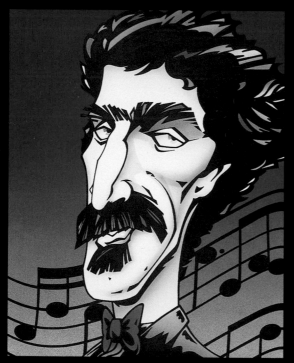

Even though the edges on a real snowman are softer than those shown here, the artist needed to render hard edges to ensure the illustration would reproduce well in a newspaper ad. Notice how the edges are slightly toned with blue to give them added definition.
Artist: Jim Effler

Hard edges give this portfolio piece its style and also show the personality of the subject, Frank Zappa. Note how soft edges are used only in the facial shadows as subtle shaping elements.
Artist: Jack Whitney

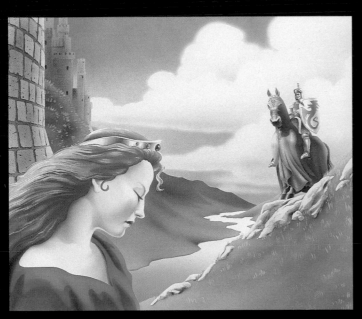

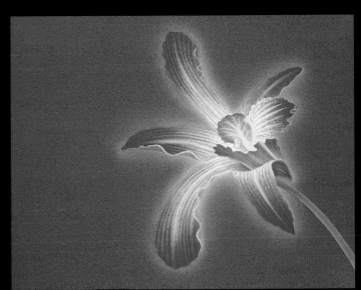

This book-cover illustration uses mostly soft edges to capture the ethereal mood of the flower and vivid colors to add drama.
Artist: Jim Effler

Edge effects are one of the joys of airbrushing because of the broad range of styles they let you render. Compare this portfolio piece to that of Frank Zappa, left. As different as they could be, both were rendered by the same artist.
Artist: Jack Whitney

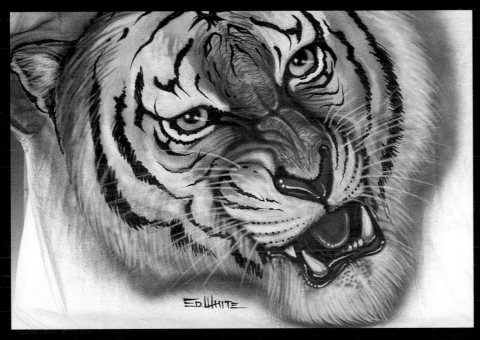

Professional T-shirt artists are skilled at creating a range of edge effects without using stencils. In this piece the artist creates hard edges by holding the airbrush very close to the surface so there is little, if any, overspray. Notice the clever use of zigzagging and branching lines to add texture and strength to the illustration.
Artist: Ed White

Chapter 6

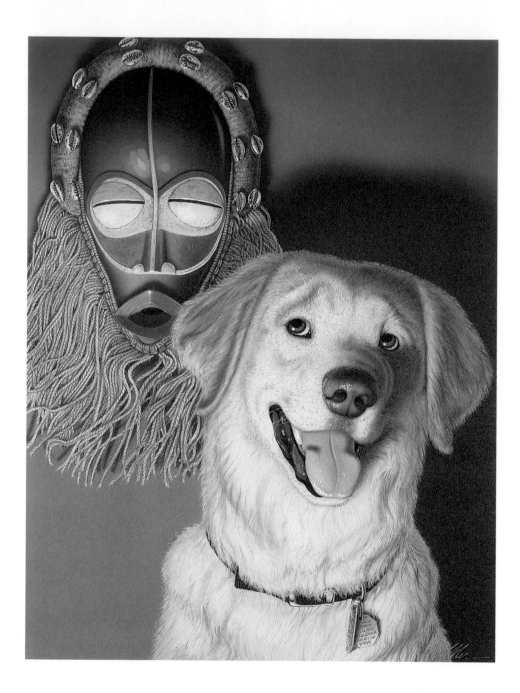

RENDERING TEXTURE

The airbrush, alone or in combination with other tools, is capable of producing dozens of textures, many of which you can see throughout this book. You can render skin, hair, grass, sand, stars, feathers, wood, stone, marble, leather and nearly any other textured surface imaginable.

Before you begin spraying a texture, study an actual example of the object. See where there are hard or soft edges, where there is detailing, how strong the contrast is between colors, and how dominant the texture itself is. This thorough exam will help a great deal in deciding which airbrush techniques to use to render these qualities.

In the following demonstrations, you'll see how to use frisket film, acetate and a sponge to create different textured surfaces.

TEXTURE BASICS

Here is a list of the most popular spraying techniques used to create common textures. All of these techniques are useful in commercial illustration. The ones that work well on the T-shirt surface are stippling, sponging, masking and coloration.

Stippling. Sometimes called spattering, stippling is spraying tiny dots to create a grainy texture. Usually you create a stippled texture by lowering your air pressure to 7 or 8 psi. Or you may buy a spatter cap that attaches to your brush and creates the stippled effect as you spray. Textures often illustrated by stippling include stone, sand and building facades.

Sponging. This creates an irregular, mottled texture. Dip a synthetic or natural sponge into your paint (full strength or diluted) and gently dab it onto the illustration board. Make sure you've masked any areas in which you don't want the sponge effect. The sponge effect can be applied on top of airbrushed color. Textures often rendered by the sponge technique include cork, marble (try overprinting sponged colors), rusty metal and shrubbery.

Dry Brush. This technique is a quick way to produce fine textures—hair, fur, wood grain, grass—that would be very time-consuming to render with a handbrush. To combine dry brush with airbrush, lay down a flat tone with the airbrush, then apply the dry brush on top. Load your handbrush with paint, then dab or wring it dry. The bristles should be spread apart in a fanlike effect. Sweep the brush gently

across the board. Vary the dry brush effect by changing the amount of paint, stroke length and color.

Erasing. Erasers are wonderfully versatile tools that are useful for rendering hard-edged or soft-edged textures, most often as highlights. Spray a light layer or gradation of color on your board and use a hard ink eraser to quickly remove paint; this creates a pattern and exposes the white board surface as the highlight. An electric eraser speeds up the process and can produce highly textured effects.

Masking. Any of the common masking or stenciling materials can be cut into patterns to create texture. Experiment with unusual masking materials, such as window screening, lace, gauze and burlap.

Color. Although you don't normally think of color as having texture, it can produce textured effects. Colors are often stippled on top of one another. For example, you can create a stone effect by stippling yellow ochre, overlaying a gray stipple and topping this with a white stipple for highlighting.

Another common texture rendered with color is wood. While it is especially helpful to have a sample in hand, the basic technique is to use lighter shades of color in the yellow/gray range, gradating them into one another, and adding darker, soft-edged bands of color to represent the grain.

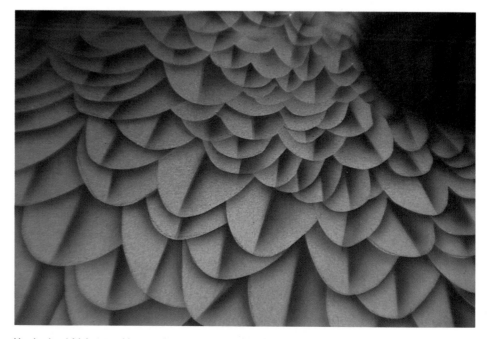

Hard-edged frisket masking produces a stronger bird feather texture.

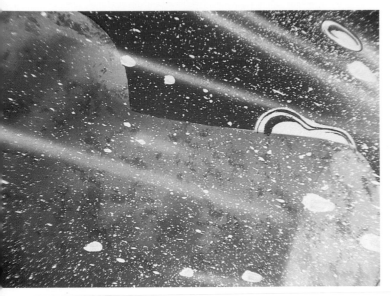

Sponging produces porous cork texture, while stippling results in a liquid spray effect.

Dry brush laid over airbrush color recreates the effect of polished wood.

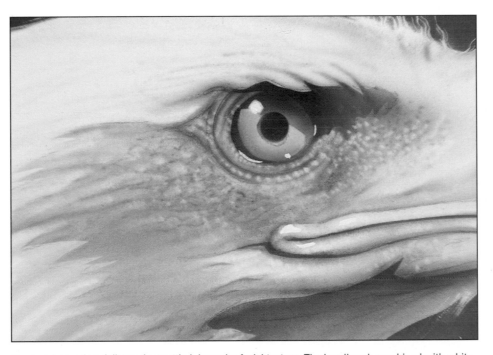

Freehand spraying delivers the mottled, irregular facial texture. The handbrush combined with white gouache lets you produce the downy feathers.

AMERICAN EAGLE

Paint: Gouache.
Colors: Deep ultramarine, azure blue, black, burnt sienna, white, violet and golden yellow.
Masking: Frisket film.
Surface: Cold-press board.
Plus: Typing eraser, no. 0 sable brush.
Techniques:
Airbrushing Freehand, pp. 8-19; Gradating Color, pp. 20-31; and Using Masks, pp. 32-43.

Step One
Cover the pencil drawing with frisket. Lightly cut around the background sky and expose this area. Starting at the top of the sky, gradate color downward, moving your brush in left to right sweeps, overlapping each pass. Begin with deep ultramarine, and finish with azure blue. Remask the background sky.

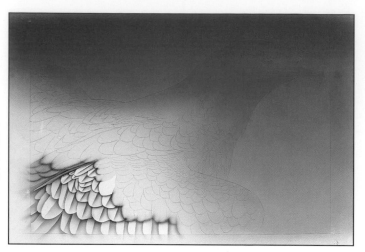

Step Two
To render the feather texture, first cut the frisket around each feather before you spray it. This step is time-consuming but necessary for creating realistic texture. Beginning in the lower left corner, expose one feather at a time and spray a light layer of black along its upper edge. Then hold the straight edge of a piece of paper in the center of each feather and add the black middle shadow. Don't remask the feathers. Work moving from bottom to top of the bird's body.

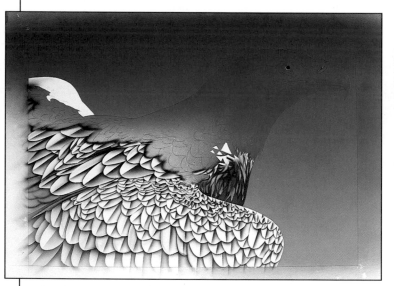

Step Three
After finishing the feathers, spray black shadows on the throat, shoulders and back. (See Step Four for specific areas.) Expose the iris of the eye and the nostril, and spray black in those spots.

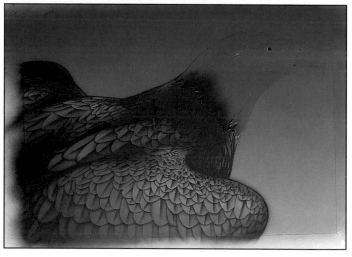

Step Four
Cover the entire feather area with a light layer of burnt sienna. Carefully spray heavy coats of burnt sienna and black for the darkest shadows of the back, neck and wing areas, keeping the spray away from the background.

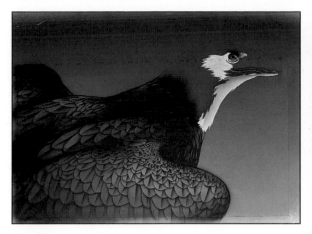

Step Five

Remove the frisket from the shadow areas of the head and lightly spray with an equal mixture of violet and black.

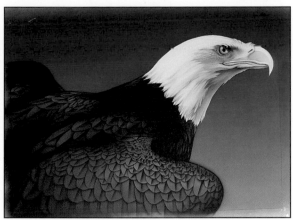

Step Six

Freehand spray warm-toned textures into the neck and head areas with light layers of golden yellow and violet. Spray golden yellow over the beak. Cut a crescent-shaped mask and spray permanent white, gradating from the top down, to create the highlight on the beak. Add golden yellow to the eye.

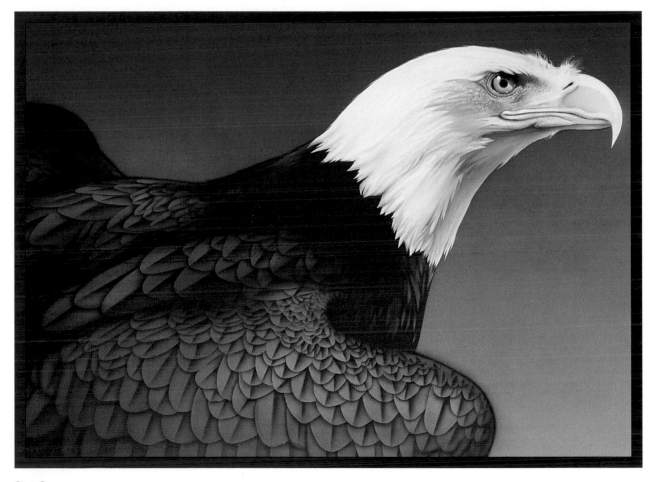

Step Seven

Handbrush the darks around the eye and the beak. Use a typing eraser to remove tone in some highlight areas to lighten them. Sharpen the eraser point for use in fine areas. Add the hardest or smallest highlights with a no. 0 sable brush and permanent white. Soften the wispy white down feathers around the beak by freehand spraying white on top of the thin handbrush lines.

CHAMPAGNE SPLASH

Paint: Gouache.

Colors: Burnt sienna, lamp black, golden yellow, permanent green light, permanent green deep, sky blue, bengal rose, deep violet, deep ultramarine blue and permanent white.

Masking: Frisket film and 3mm acetate.

Surface: Cold-press board.

Plus: Natural sponge, no. 0 sable brush, toothbrush.

Techniques: Airbrushing Freehand, pp. 8-19; Gradating Color, pp. 20-31; and Using Masks, pp. 32-43.

Step One

Cover the base drawing with frisket and cut along all cork and foil lines. Expose the cork and gently press a natural sponge wet with burnt sienna onto the board. Spray lamp black freehand to add shadow tones. Expose the shadow areas on the foil and spray lamp black, gradating from the edges inward.

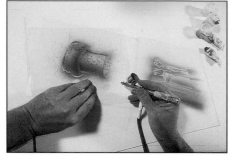

Step Two

Expose the rest of the foil. Spray a light layer of golden yellow over the cork and the foil. Hold an acetate mask that exposes the rest of the cork. Spray burnt sienna to deepen shadows and add overall tone to the cork.

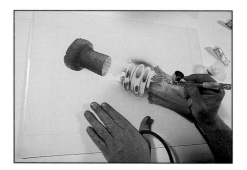

Step Three

Remove the remaining masking and re-cover the illustration with fresh frisket. Cut along the bottle neck and the champagne splash. Remove dark areas first from the neck; leave the neck's highlights and the splash covered. Spray lamp black working from the outer edges inward. Then spray permanent green light.

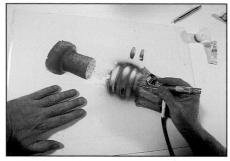

Step Four

Expose the neck's highlights and spray permanent green deep, gradating the color into the highlights.

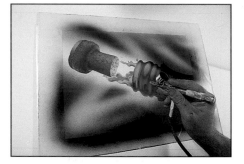

Step Five

Expose the splash and spray a light layer of bengal rose. Add a light layer of sky blue and permanent green light to adjacent areas. Paint the bottle cap first with deep violet in the shadow; finish with a light layer of bengal rose. Cover the painted areas with fresh frisket and expose the background. Spray lamp black randomly to create areas of visual interest. Go over the background with a light layer of deep ultramarine blue.

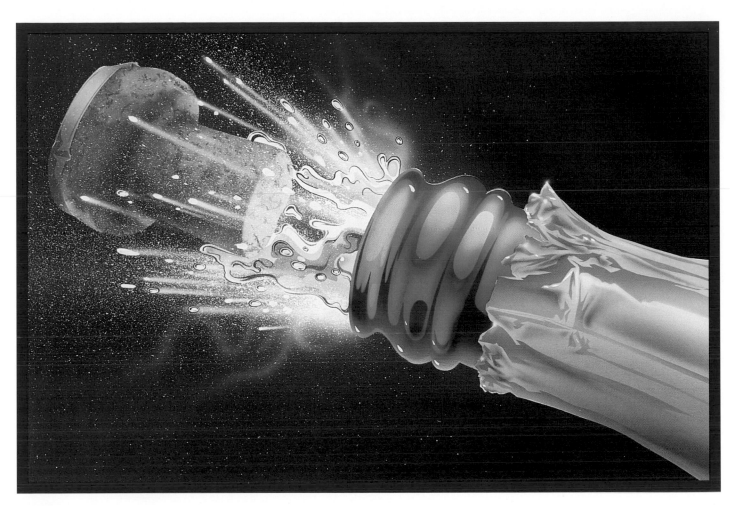

Step Six

Create the white stipple texture by loading a toothbrush with permanent white and flicking it with your thumb in the direction of the splash. (Practice this before stippling your illustration.) Spray a light white mist over the stippling. Handbrush the line work to refine the splash.

PROFESSIONAL PORTFOLIO

The handbrush is one of the most important tools for rendering wood texture, such as the sleek, polished surface of this violin. Notice how the illustrator of this newspaper ad uses different stroke lengths for different wood effects.
Artist: Toby Lay

Stippling is the technique used by artists to render sand. When you want to produce a textured effect, try the stippling method used here to add shaded areas: Stipple multiple layers of color beginning with lighter tones overall and ending with darker tones only in the shadow areas.
Artist: Jim Effler

Compare the sand rendered here to that in the illustration of the sand castle above. For this greeting card image the artist first laid down a gradated base tone, over which he added a much coarser stippling pattern. He continued this pattern into the wall to unify the illustration and add a sense of playfulness.
Artist: David Miller

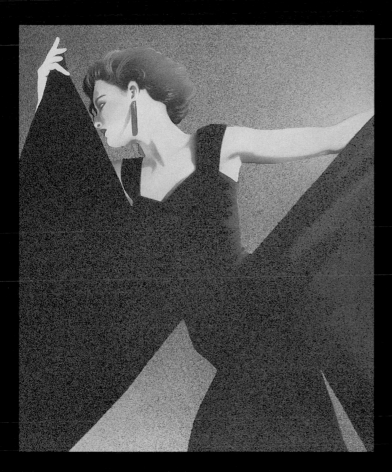

This portfolio piece shows an effective use of stippling for a dramatic fashion image. Although stippling is used over the entire piece, notice how the artist uses neutral colors on the flesh and darker colors throughout the shadow area. Also note how the darker stippling serves to define the outline of the woman's flesh areas.
Artist: Jack Whitney

Animals are fun to illustrate because of the variety of textures on their bodies. Dry brush was used extensively for the dog's fur and whiskers in this self-promotion piece. Handbrush work adds details and highlights to the nose and mouth.
Artist: Jim Effler

Chapter 7

APPLYING HIGHLIGHTS

Highlights serve many uses in airbrush illustration. They create the illusion of solidity, put the sparkle on a metallic surface, or produce the starburst effect popular in T-shirt illustration. How your highlight is used determines the technique you should use. If you study how the illustrations in this book use highlights, you'll notice a key difference among them: their edge quality.

Highlights can be soft or hard edged, and the methods for rendering these highlights are similar to those you use to create different line effects. Freehanding, handbrushing and erasure produce soft highlights; masking produces hard highlights.

The following projects illustrate how to use liquid frisket, acetate and frisket film to render reflections in water, off plastic, on metal and on a painted surface.

HIGHLIGHT BASICS

You can render highlights using any of a number of techniques. The information below describes the most common ones.

Freehanded or Handbrushed Highlights

These give a satiny effect to an object and are relatively easy to render. First, decide where the highlights are located on an object by determining the direction from which the light is coming. Spray or brush a little white paint at the brightest center points of these highlights and fade the highlight away from this light source. Often an "X" or a cross shape is placed at the center of a highlight.

Erasure

This popular method renders soft highlights and is especially suitable for facial highlights, such as in the "Pretty Woman" project on pages 36-38. The best tool to use is a hard ink eraser because its sharpening ability gives you maximum control over how much you erase and it can aggressively remove paint.

The process is simple: Spray a light coverage of paint and gently remove or "erase" the color in the highlighted areas. Repeating this process of spraying and erasing builds both color and tone surrounding the highlights. Try not to erase a heavy layer of paint. The objective is to erase just down to the board surface, letting its whiteness become the highlight. You can't erase through heavy paint and successfully expose the board.

Masking

Hard-edged highlights are associated with very shiny surfaces, such as steel or glass. Large highlights are produced by masking, that is, covering the highlight with frisket film or acetate and spraying the object's color around the highlight mask.

When the mask is removed you are left with a stark, white highlight. You can soften this highlight, if desired, by spraying the object's color near the unmasked highlight so that some paint overspray hits the highlight.

Small highlights are produced by cutting the highlight shape out of acetate and spraying white through this mask. This effect can be softened further by freehand spraying a glow around the highlight.

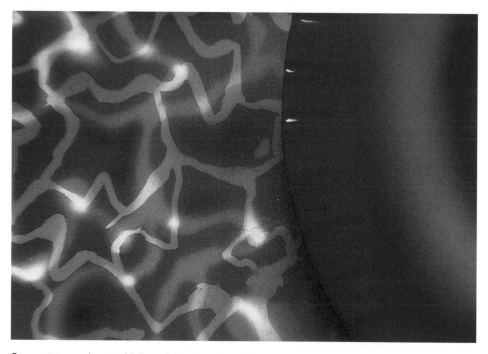

One acetate mask, cut with irregularly shaped openings, is used repeatedly across the water area to produce these shimmering highlights.

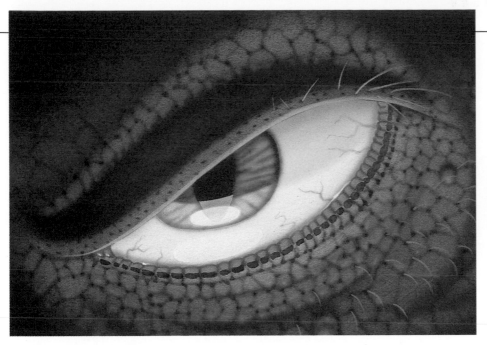

These elliptical highlight shapes are sprayed through acetate masks with different degrees of brightness to add drama to this eye.

A simple starburst adds the finishing sparkle to an object.

All highlights are not created equal. Color added to a highlight can make it work more cohesively with the reflective surface.

The handbrush and white gouache are used to add subtle highlights to these eyes.

POOL TOY

Paint: Gouache.
Colors: Periwinkle blue, azure blue, permanent white, orange lake deep, bright orange fluorescent and light purple.
Masking: Frisket film, 3mm acetate and liquid frisket.
Surface: Cold-press board.
Plus: Compass knife, white artist's tape, nylon handbrush.
Techniques:
Airbrushing Freehand, pp. 8-19, and Using Masks, pp. 32-43.

Step One

Cover the entire drawing with frisket and use a compass knife to cut along the circular inner tube lines. Remove and save the water frisket. Apply liquid frisket with a nylon handbrush along the irregular, snaking lines.

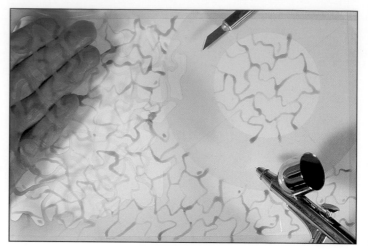

Step Two

To render highlights in the water, cut an acetate mask with irregular, snaking lines similar to those drawn on the board. (The mask is sprayed blue here so you can see it.) Hand-hold this mask on the board at cross angles to the liquid frisket lines and spray periwinkle blue. The resulting lines will be soft-edged since some underspray will slip beneath the mask.

Step Three

Spray a periwinkle blue shadow beneath the inner tube. Spray the entire water area with azure blue to add light tone to the acetate highlights. Darken the blue inner tube shadow with more periwinkle blue.

Step Four

Remove the liquid frisket using white artist's tape and expose the hard white highlights; these will be your strongest highlights. Position the mask from Step Two in the same place on the board where you first sprayed through it. Spray azure blue to add tone to these liquid frisket highlights. The result is white highlights where the two sets of snaking highlights intersect. Soften these intersections and add extra sparkle by spraying permanent white at their center points.

Step Five

Reposition the water frisket from Step One and uncover the inner tube. Cut a curved acetate mask with a serrated edge. Hand-hold this mask in place, moving it around the inner tube as you spray orange lake deep to create these edge effects. Cut two circular masks out of acetate, one the size of the inner tube's inner circle, the other the size of its outer circle. These will help you add shadow, shape and volume to the tube. Position the larger mask and spray orange lake deep through it, moving it slightly back and forth as you go. Repeat with the smaller mask.

Step Six

Spray bright orange fluorescent over the entire inner tube. Freehand permanent white highlights.
Remove all the frisket and freehand spray light purple in the shadows around the inner tube.

MERCEDES HOOD ORNAMENT

Paint: Gouache.
Colors: Lamp black, ultramarine blue deep, light purple and azure blue.
Masking: Frisket film and 3mm acetate.
Surface: Cold-press board.
Technique: Airbrushing Freehand, pp. 8-19; Gradating Color, pp. 20-31; and Using Masks, pp. 32-43.

Step Two
Repeat Step One using ultramarine blue deep and again with light purple at the horizon.

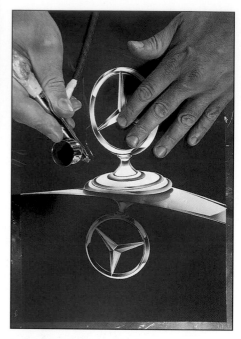

Step Four
Use this same technique to spray highlights in the hood ornament's reflection. Protect the actual chrome with acetate and spray a light layer of ultramarine blue over the reflection.

Step One
Cover the drawing with frisket film and lightly cut along all lines. Expose the background and the car hood, leaving the chrome and reflection covered. Using lamp black, gradate the background from the top down. Protect the background with acetate and gradate lamp black over the car hood from the top edge of the hood down.

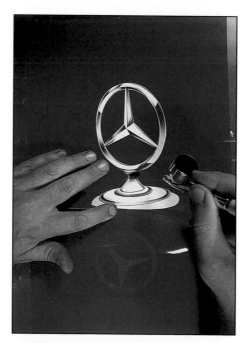

Step Three
To create areas of dark reflection, remove the frisket one piece at a time and spray lamp black. Cut crescent-shaped acetate masks to aid in spraying the hard-edged highlights.

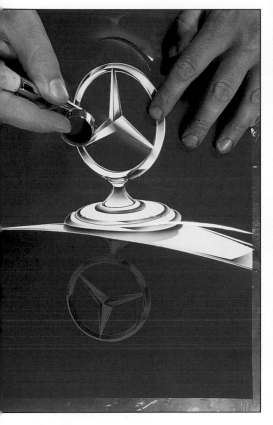

Step Five

Again using clear acetate, cut masks for the blue reflections on the actual chrome and gradate azure blue through these openings. To help you position these reflections, imagine that the blue is the reflecting sky color.

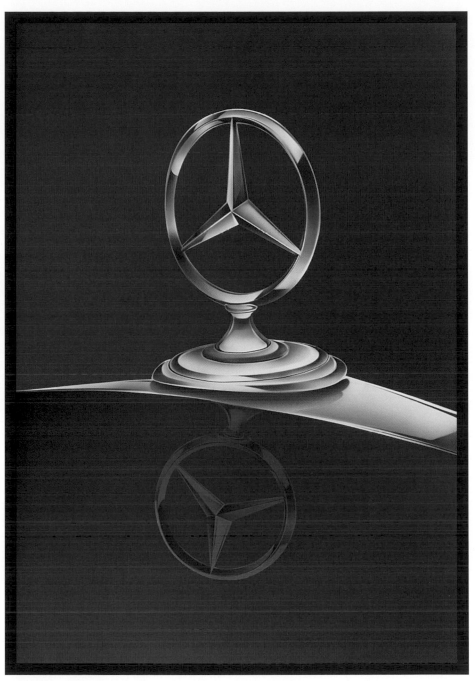

Step Six

Finish the piece by freehanding light purple in select areas on the chrome.

PROFESSIONAL PORTFOLIO

This billboard image uses highlights across the [key]board so that every object is featured in pristine realism, almost like in a photographic studio shot.
Artist: Toby Lay

In this advertising illustration, highlighting is used primarily to create a spotlight effect for the product. Notice how the water droplets reflect the color of the beer cap, but the highlights on the droplets are kept white for maximum sparkle.
Artist: Jim Effler

Highlighting not only makes the products in this advertising illustration glisten, it accentuates their curvedness and implied motion.
Artist: Toby Lay

The flared highlights in this T-shirt image enhance the glamour and brilliance of spotlights focused on Jimi Hendrix.
Artist: Ed White

Slender white highlights are the finishing touches on water droplets. Notice the pattern of the highlights in this magazine ad: The longer ones are all on the side of the droplet that is being hit by light while opposite each is a small, dot highlight.
Artist: Jim Effler

These eyes would be nerve-wracking enough without the highlights; with them viewers can expect a sleepless night after seeing this magazine ad. The large highlights across the eyes were sprayed through an acetate mask, and the smaller ones through an ellipse template.
Artist: Jim Effler

Chapter 8

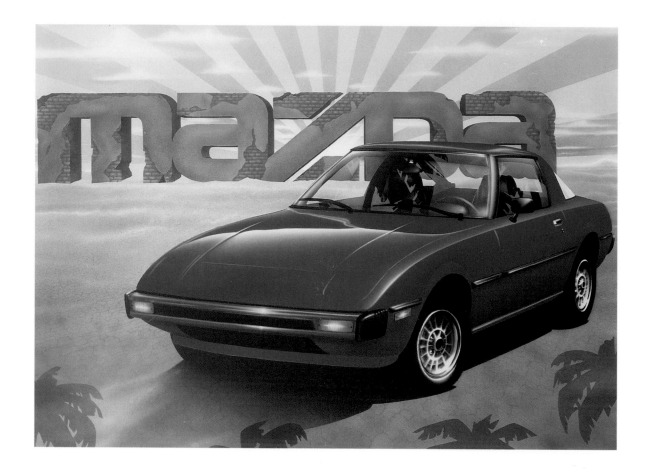

CREATING METALLIC EFFECTS

Metallic surfaces feature many distinctive characteristics that you should note in the objects you see every day. A brand new car, reflective lenses in sunglasses, a doorknob, and other common objects can teach you how light reacts to metal, where highlights fall, how strong the contrast is between darks and lights, how reflected colors work, and whether reflected elements should be hard or soft edged.

Surround yourself with reflective objects for reference when rendering metallic images. Toy cars and chrome parts are helpful aids. Your study of real-life reflections will quickly teach you how to render them in your illustra-tions, whether on board or T-shirt surfaces.

The following step-by-step demonstrations show you how to render popular metallic lettering (note the horizon line through the middle of the letters) and the reflective painted and metallic surfaces of a car.

METALLIC EFFECT BASICS

The key characteristic of the shiniest metallic surface is the strong contrast between dark and light tones. As you diffuse this contrast (by softening the edges and bringing the tones closer together), the surface dulls, and your shiny-looking steel will look more like aluminum. If the contrast fades too much, the surface will simply look like it's painted rather than reflective.

Another characteristic of metallic surfaces is gradated color that reflects the color of objects near its surface. A third quality, which is always the finishing touch that makes a surface pop and sparkle, is bright highlights.

Classic metallic lettering is illustrated with the traditional horizon line that represents reflectivity. You can see this on page 80-81.

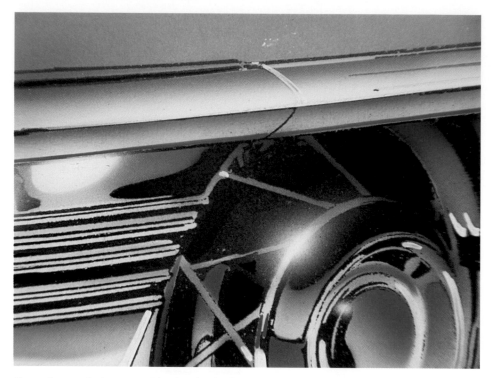

Car surfaces reflect a range of hard and soft edges and shapes, and gradated colors.

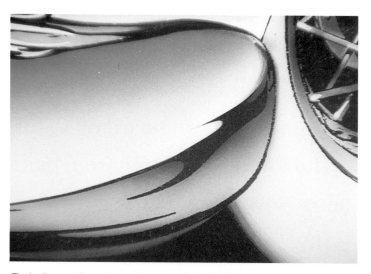

Typically, metals such as chrome and steel reflect gradated sky and horizon colors.

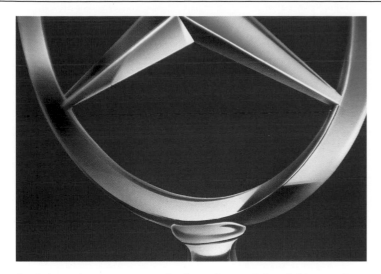

Gradation and contrast are two dominant characteristics of shiny metal.

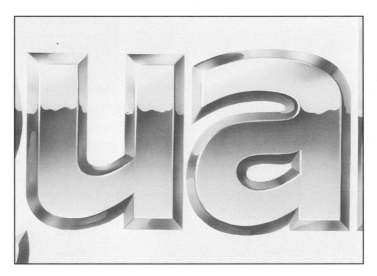

Chiseled metallic lettering reflects the horizon on all sides.

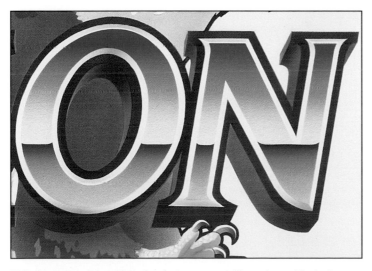

This three-dimensional lettering features a metallic surface with single-toned sides so it blends with the background image.

GOLDEN LETTERING

Step One

Cover your drawing with frisket film and cut along all lines. Expose the letters from the horizon line down and gradate primrose yellow. Repeat with burnt sienna, but spray only half of the gradated area. Repeat again, one-quarter of the distance, with black. Remask these areas.

Step Two

Remove the frisket from the triangular shield behind the letters and the horizontal plate beneath "Golden." Use the gradation and color sequence from Step One, stopping at the horizon line and using very little black. Handhold a piece of paper over "Golden" as you spray the horizontal plate and over the plate when you spray the triangle at the bottom.

Step Three

Re-cover "Golden," the plate, and the triangle with the existing frisket. Expose the right sides of both the letters and panels and gradate the same three colors in the sequence described in Step One. Re-cover these areas, expose the chiseled areas inside the letters, and spray the same color sequence again. Then expose the bottom sides of the letters and panels, and repeat the sequence.

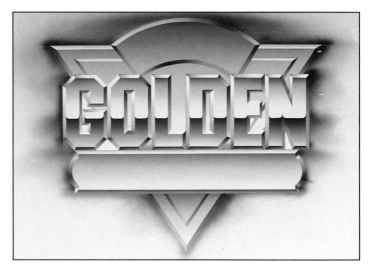

Step Four

Imagine that the light is hitting the letters from the upper left and, with lighter tones, repeat Step Three for the top and left sides of all surfaces to render the highlight effects.

Paint: Gouache.

Colors: Primrose yellow, burnt sienna, black and white.

Masking: Frisket film and paper (any kind).

Surface: Hot-press board.

Techniques: Gradating Color, pp. 20-31; and Using Masks, pp. 32-43.

Step Five

Use the techniques on the previous page to airbrush additional lettering. Use white paint to airbrush the highlights to these letters.

HOT CADDY

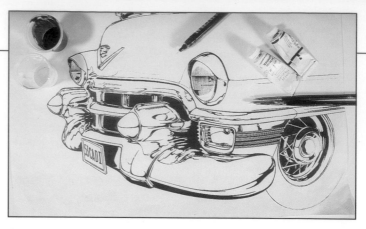

Paint: Gouache and watercolor.

Colors: Watercolor—black; gouache—white, burnt sienna, azure blue, lamp black, light purple, fluorescent yellow, fluorescent magenta and permanent white.

Masking: Clear 3mm acetate.

Surface: Airbrush paper.

Plus: Tracing paper, mechanical pencil with H lead, mechanical pen or fine nib marker and no. 0 sable brush.

Techniques: Airbrushing Freehand, pp. 8-19; Gradating Color, pp. 20-31; and Using Masks, pp. 32-43.

Step Two

Photocopy the drawing onto regular white copier paper and clean up the lines further using a technical pen or a fine nib marker, white gouache and black watercolor.

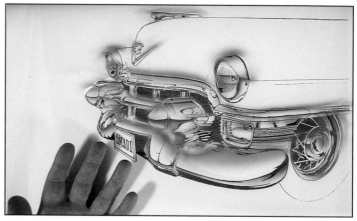

Step Three

Photocopy this version again onto airbrush paper and mount the paper onto board with spray adhesive. Cut an acetate mask to expose the areas where you envision ground reflections and spray burnt sienna. Use another acetate mask to spray azure blue for sky reflections.

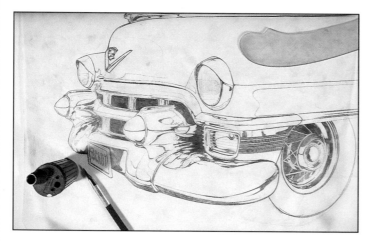

Step One

Using a color copier, enlarge a 35mm slide and make an 11-by-17-inch print. Lay tracing paper over the photocopy and use the mechanical pencil with H lead to sketch the Caddy, simplifying lines in the chrome. Use ellipses and templates to capture lines, as necessary. Shade in the darkest shadow areas.

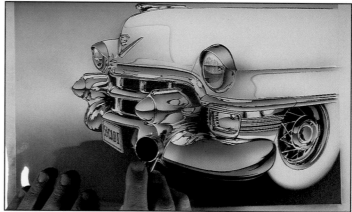

Step Four

To render a soft-edged base shadow, spray lamp black through a third acetate mask, moving it as you spray. Spray burnt sienna over the base shadow and gradate it up to the horizon. Gradate the sky with azure blue down to the horizon. Cut an acetate mask to add light purple shadows to the car body.

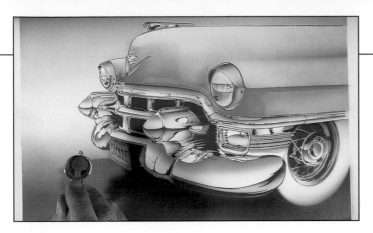

Step Five

Expose the car body and spray fluorescent magenta. Spray fluorescent yellow freehand into select areas, using acetate masks as necessary to protect other colors.

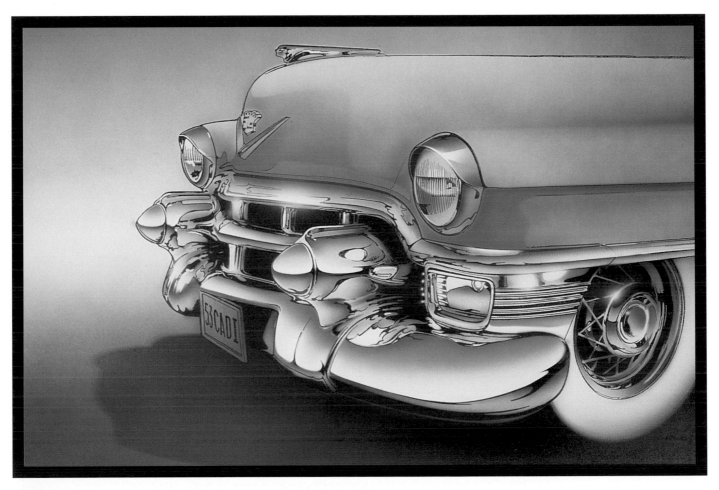

Step Six

Finish by handbrushing white detailing and highlights with a no. 0 sable brush. Cut acetate masks to expose only the horizon line areas in the reflections and spray permanent white, gradating it into each sky reflection.

PROFESSIONAL PORTFOLIO

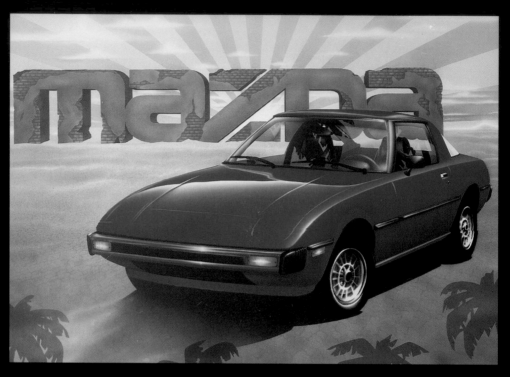

Notice how in this portfolio piece gradation is critical in showing this as a shiny, new sports car.
Artist: David Miller

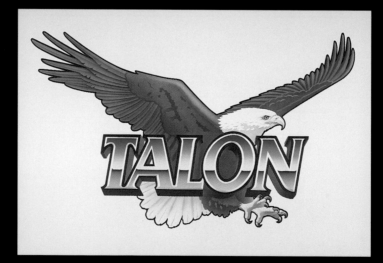

The classic horizon line is evident in this metallic, three-dimensional letter-
ing. What makes this advertising illustration of an eagle in flight unique is
the clever addition of a body of water as the horizon.
Artist: Jim Effler

Sensitivity about the purpose of an illustration is important. In this advertising piece, the need was to epitomize "Quality"; the artist did so by using gold tones, even in the reflecting horizon line.
Artist: Joe Taylor

Study the relationship of the lettering to the neon lights. Note how the red neon reflects only on the facing surface of the bottom word and on the under surface of the top word. This accurate rendering of viewpoint and reflection indicates an artist who really looks at the relationship between elements of his subject matter.
Artist: Toby Lay

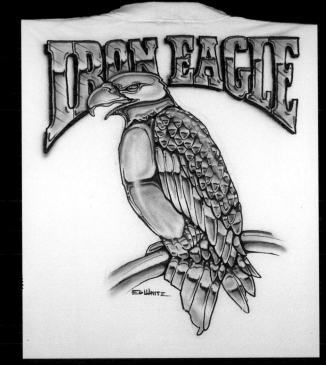

As you see here, the same basic elements of reflectivity are used to render metal on a T-shirt: horizon line, gradation, contrast and highlights.
Artist: Ed White

Chapter 9

RENDERING LETTERING

Lettering is a common and popular element in commercial and T-shirt art. The versatility of the airbrush makes it fun and rewarding since you can render any lettering style.

As you explore lettering styles you must also become aware of specific techniques and masking materials that are necessary for creating lettering that is realistic and attractive.

The following three step-by-step demonstrations show how to render the popular neon, script and metallic block lettering styles. The basic techniques for these styles are suitable for use on illustration board or T-shirts. Your masking technique will vary depending upon your application.

LETTERING BASICS

It's important that you plan any lettering before diving into a project. Design your lettering with the same attention you would an illustration. Do rough sketches, then modify and refine them to produce a tight, polished lettering drawing.

If you are lettering on a T-shirt, now's the time to start practicing what many pros have learned from experience: Keep your lettering design simple. Since profitability in T-shirt art ultimately relies on quality, quantity and speed, you need to learn how to render lettering that is expressive, yet easily done.

Block lettering (see pages 94-95) and script lettering (see pages 92-93) are popular T-shirt lettering styles. You can also purchase precut lettering stencils as an aid until you can freehand draw lettering. Avoid letters with serifs (the short lines that run perpendicular to the beginning and end of a letterform), as these are difficult to render consistently.

Planning should go hand in hand with practice. Practice drawing various letterforms and spraying them with and without stencils. There is an abundance of typography books available in the library and in art supply stores that you can borrow or buy for reference. It's quite all right to photocopy pages and duplicate the letterforms to create your own words. The sizing feature on the photocopier saves time, letting you enlarge or reduce the letterforms as needed. Believable lettering needs careful construction. All the components—arms, serifs, crossbars—of each letterform must

be proportional. The letterforms within words must be proportional and consistently styled. Sloppiness will jump out at a viewer as quickly as if you had misspelled the word.

You can add texture, color, highlighting and three-dimensionality to lettering just as you can to an illustration. See the chapters covering these elements for specific airbrushing techniques.

Metallic lettering typically features gradated sky and horizon reflections.

Block lettering is easily produced using a type book as a visual reference and frisket film to ensure hard, clean edges.
Artist: Joe Taylor

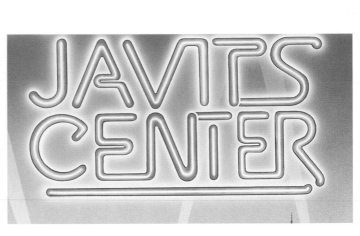

Neon lettering is basically outlined letterforms, within which are colored outlines and white center areas.

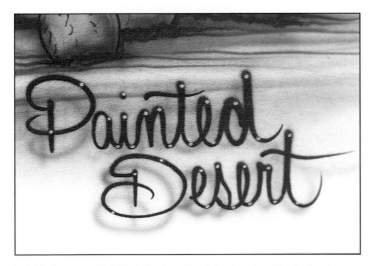

Script lettering on T-shirts is best rendered freehand so it looks hand-written and flowing.

A drop shadow is rendered just like the dominant letter, whether you are masking or freehanding.
Artist: Dan Shannon

89

LOVE IN MY HEART

Paint: Gouache.
Colors: Ultramarine blue and scarlet lake (or red).
Masking: Frisket film and 3mm acetate.
Surface: Cold-press board.
Plus: French curve and circle template.
Technique: Airbrushing Freehand, pp. 8-19; Gradating Color, pp. 20-31; and Using Masks, pp. 32-43.

Step One
Position your drawing on the illustration board using the lead pickup technique described in chapter one. Lightly cut along the drawing lines. Remove and save the frisket pieces from the shadow areas shown and spray ultramarine blue.

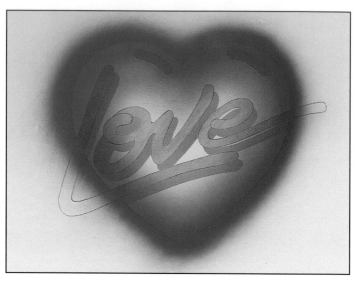

Step Two
Remove the frisket covering the heart. Spray scarlet lake (red) just inside the line drawing. You can spray over the ultramarine blue. Gradate this color inward, keeping the middle lighter to give roundness to the heart.

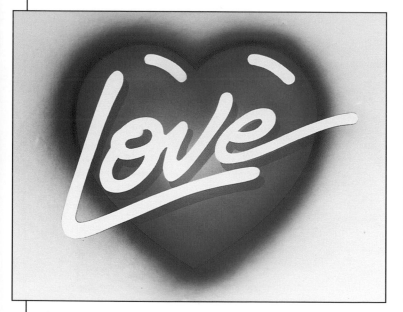

Step Three
Re-cover the red heart, then remove the "Love" and reflections frisket. Cover the shadows so they won't receive additional tone or density.

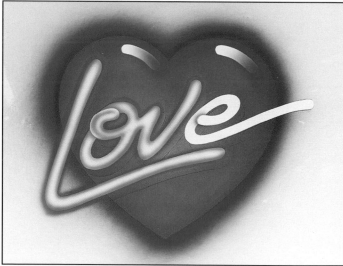

Step Four
To create the neon effect, spray ultramarine blue around the edges of the lettering. Overspray will add slight tone to the middle of the letters. Freehand spray and gradate the red on the right sides of the reflections.

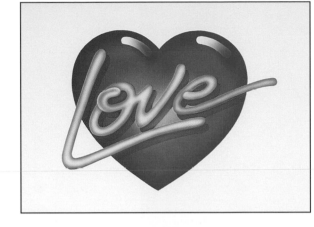

Step Five
Remove all the frisket.

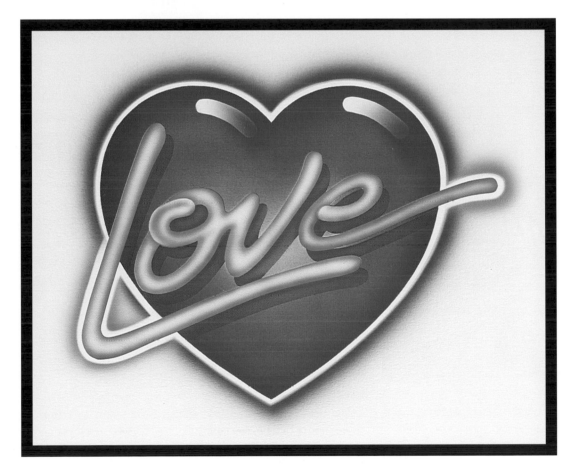

Step Six
Using a French curve, circle templates and a 3mm piece of acetate, create an opening that is one-quarter inch larger than the outside shape of the image, cutting around the corner of the "L" and the tail of the "E." Holding the mask by hand, move it slightly from left to right and up and down to soften the edges as you spray a red glow around the heart and a blue glow around the letters.

ELVIS AND TCB

Paint: Acrylic fabric paint.
Colors: Black, fluorescent magenta, blue and white.
Masking: None. Freehand.
Surface: T-shirt.
Technique: Airbrushing Freehand, pp. 8-19.

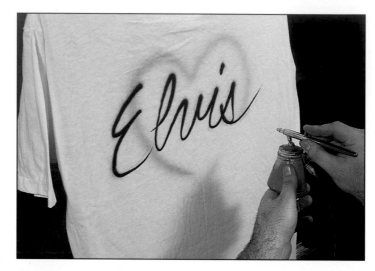

Step One
Apply your base drawing to the T-shirt. Outline the drawing with black paint. You can touch up the black outline with a second spraying, if needed. Mist in the fluorescent magenta heart shape, holding the brush one inch from the T-shirt.

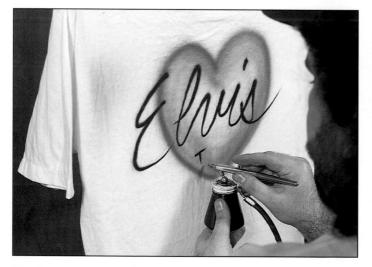

Step Two
Darken the heart outline, then fill it in leaving the center lighter to create dimension. Add the "TCB" (Taking Care of Business) letters.

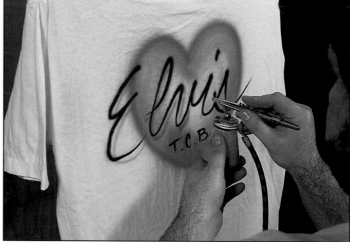

Step Three
Add the blue drop shadow behind the script lettering. Hold the airbrush one to one-and-a-half inches from the surface so the shadow is diffused.

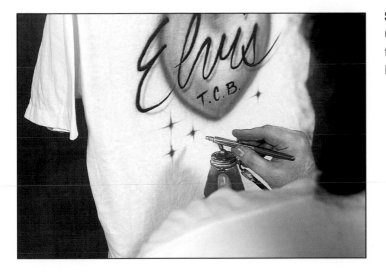

Step Four

Create the starbursts by spraying heavy color at the center points; fade the color out along the arms by decreasing paint flow and moving the brush away from the shirt. Keep air pressure constant at 40 to 50 psi.

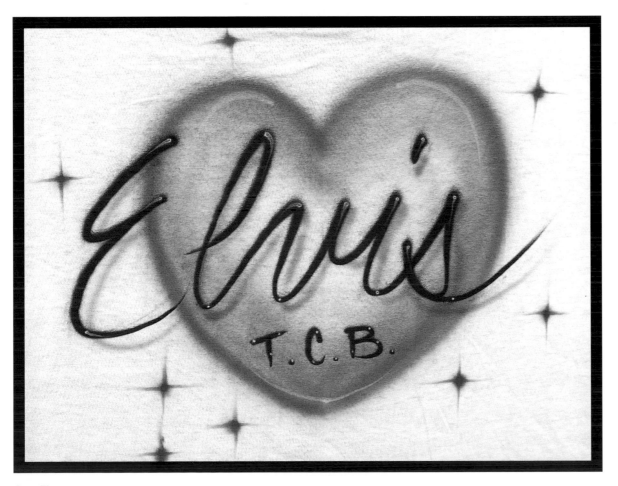

Step Five

Finish the piece by adding white highlights on all the letters to give them shape.

THE DOORS

Paint: Acrylic fabric paint.
Colors: Black, brown, royal blue and white.
Masking: None. Freehand.
Surface: T-shirt.
Technique: Airbrushing Freehand, pp. 8-19, and Gradating Color, pp. 20-31.

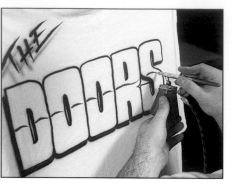

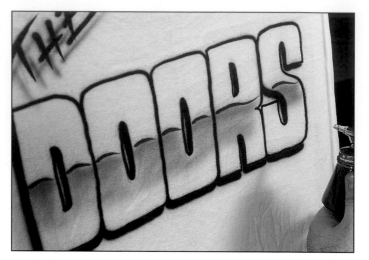

Step One

Hold the airbrush close to the shirt and outline the letters in black. Repeat for "The." Move the brush farther from the shirt and, pulling back on the trigger only a little, add a light black (gray) drop shadow to "The." Add a brown horizon line through the center of each of the "Doors" letters.

Step Two

Holding the brush about two inches from the shirt gradate brown from the horizon line down.

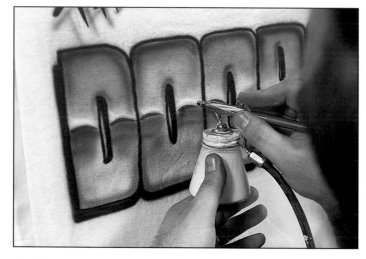

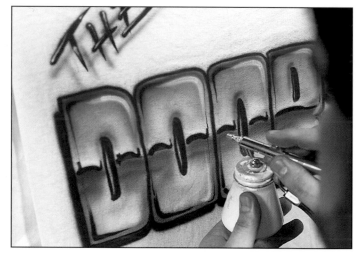

Step Three

Gradate royal blue from the top of the letters down to the horizon line. Spray white lines along the top of the horizon lines to increase contrast.

Step Four

Add black reflection lines to the shadow sides and corners of the letters. Add white highlights to the corners opposite the shadow corners.

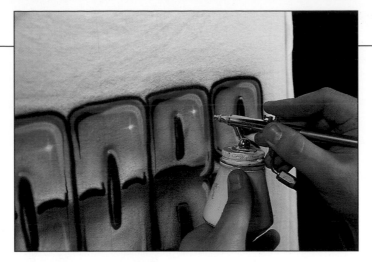

Step Five

Give sparkle to the letters by spraying four tapered lines on each. First spray a solid white dot and spray outward from the dot, lessening the amount of paint you spray as you near the end of each line.

Step Six

Add white diagonal highlights across the letters to finish the metallic look.

PROFESSIONAL PORTFOLIO

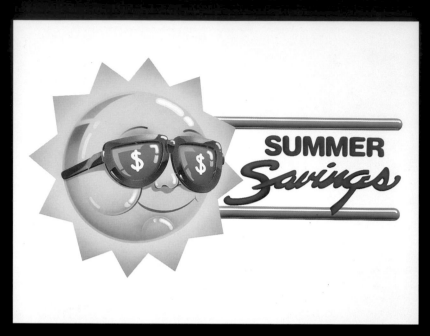

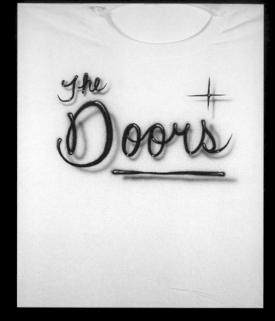

This advertising lettering combines round-edged block lettering with three-dimensional script. Darkening the tone on the shadow side of the letters gives them shape and substance.
Artist: Toby Lay

Three-dimensional script lettering is easy to create on a T-shirt just by adding white highlights and a drop shadow.
Artist: Ed White

This unique plastic-looking lettering was created with hard-edged masking and color gradation. Note how evenly toned the color is to mimic plastic.
Artist: Jim Effler

Because this is an artist's portfolio piece, he had total freedom to create the wackiest lettering he wanted. The letters were masked with frisket and the inside squiggles with acetate.
Artist: Phil Stephens

This garment tag lettering was created using a stencil burner to cut an acetate mask. The gradated colorations come from overlapping each sprayed color with the color following it.
Artist: David Miller

This pipe cleaner lettering required extensive hand brushwork to render the texture. The artist first laid tone into each letter; notice how the colors overlap slightly so the lettering looks continuous. He then hand-brushed the fuzzy detailing in multiple layers.
Artist: David Miller

Chapter 10

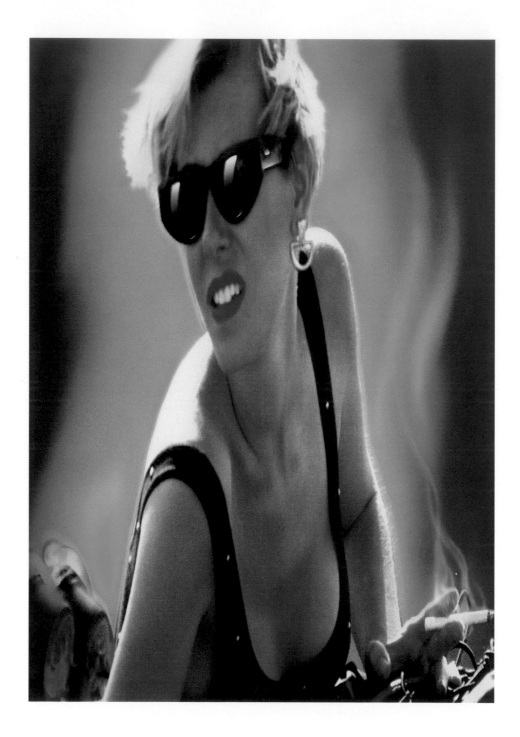

HANDTINTING PHOTOGRAPHS

One of the delights of handtinting black-and-white photographs is that there are no cast-in-stone rules. There are specific techniques to use, but the joy comes from creating unique photographic effects by handtinting with your own color palette: bright and bold, soft and moody, or realistically natural.

Handtinting lets you accentuate certain elements, create atmosphere, or just decorate the image. You can produce a one-of-a-kind color rendering of the print or, by using different color combinations or by coloring different areas of the print, create a provocative handtinted series of the same photograph.

This chapter shows two step-by-step demonstrations, one using two colors and the other using many colors. The techniques shown are essentially the same for both projects. The differences lie in masking, which is slightly more involved in the second project due to the number of colors used.

HANDTINTING BASICS

You want to start with a good original photograph and, by handtinting, make it better. Don't use handtinting as a cover-up technique, since this usually serves to emphasize rather than disguise a picture's flaws.

Your choice of handtinting colors plays a large part in establishing mood, space and dimension in your photograph. Many artists choose to handtint a photograph as realistically as possible, using colors that are true to the original subject. Keep in mind that color doesn't exist only on an object, but is apparent in shadows and reflections. You can "play" with a photograph by being less realistic about its colorations; use "wild and crazy" colors, fluorescent paints or flat, silkscreen-quality toning for special effect.

The airbrush gives you an evenly toned wash of color or fine detail. Before having a go at an actual photograph, practice with your brush on a throwaway photograph using whatever airbrushing paints you have at hand. You should also practice masking and cutting on a practice photograph, since being too heavy handed at this stage can ruin the print.

Handtinting uses frisket film and acetate for masking. Choose your masking material by the edge quality you want. Remember to secure the photograph to a stable surface using low-tack artist's tape or spray adhesive before you do any masking or spraying.

Build up colors on a photograph in layers slowly. This gives you con-

trol over a color's density and prevents overcoloring. Always remember to rinse your brush's paint cup thoroughly between colors.

The most common mediums for handtinting are water-based gouache or dye. Ultra-transparent dye colors are absorbed into the photograph's emulsion and give you a delicate luminosity that works beautifully on photographs. Gouache, which sits on the emulsion, is opaque and is good for covering areas you want eliminated.

Always prepare a photograph for handtinting by cleaning off grease or dirt using rubber cement thinner and make sure the photograph is completely dry before you begin coloring it.

PROFESSIONAL PORTFOLIO

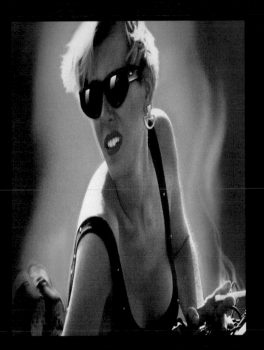

Handtinting uses color not only to enhance the photo's subject but also to create a more interesting background. In this 4-by-5 inch portfolio piece, the smoky green background provides a soft frame for the subject.
Artist: David Miller

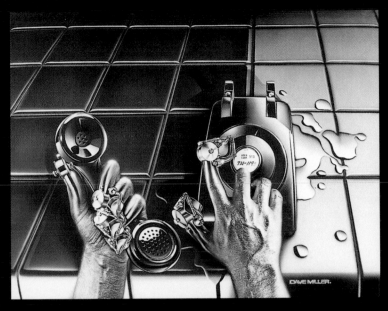

The artist began with this black-and-white retouched photo composite. The piece, which depicts the airbrush as an extension of the hand, would be used as a self-promotional poster.
Artist: David Miller

Handtinting doesn't require an extensive palette to achieve an effective image. This photo, used as an advertising poster, was handtinted using only two colors.
Photograph: Tom Rogowski
Artist: David Miller

Color enhancement of the image succeeds in displaying the creative and fanciful qualities possible with airbrush art.
Artist: David Miller

BEACH BOY

Paint: Transparent dye.
Colors: Cyan and scarlet red.
Masking: Frisket film.
Surface: Black-and-white photograph.
Technique: Airbrushing Freehand, pp. 8-19; Gradating Color, pp. 20-31; and Using Masks, pp. 32-43.

Step One
Start with a contrasty print that is one to two stops lighter than normal. Cover it with frisket film and very gently cut around all the areas you want to spray, being careful not to cut into the photo's emulsion. Expose the car body and spray cyan. Repeat to darken the tone.

Step Two
Uncover the ocean and spray cyan, gradating the color from the horizon down to the shore. Repeat this process for the sky.

Step Three
Remove all the masking and re-frisket the area around the car interior. Cut and expose these areas and spray scarlet red.

Step Four
Remove the frisket.

WILD MAN

Paint: Gouache and dye.

Colors: Gouache—black, permanent white and fluorescent green; dye—magenta, red, blue and yellow.

Masking: Frisket film and clear acetate.

Surface: Black-and-white photograph.

Techniques: Airbrushing Freehand, pp. 8-19; Gradating Color, pp. 20-31; and Using Masks, pp. 32-43.

Step One

Cover a black-and-white photo with frisket. Carefully cut around the glasses, teeth, face, shirt and background. Expose the glasses lens and spray black. Cut highlights into a piece of clear acetate and spray permanent white over the lens, gradating the color from left to right.

Step Two

Remove all the frisket from the glasses and spray magenta. Expose the mouth and spray red. Gradate these colors as shown.

Step Three

Expose the shirt and spray blue.

Step Four

Uncover the background and the hair; cut an acetate mask to protect the painted areas. Hold this mask in place and spray yellow.

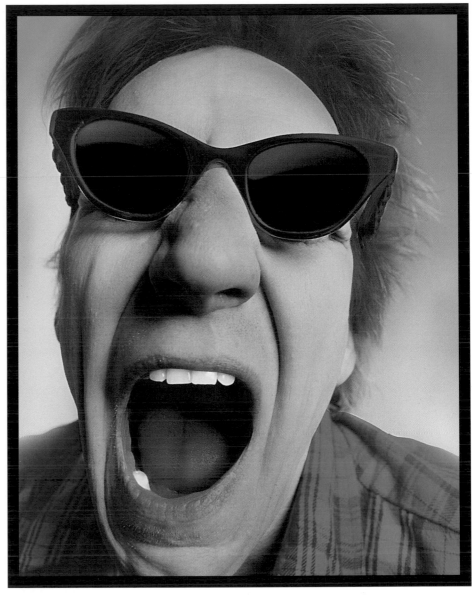

Step Five

With the masks still in place, freehand spray red along the hairline and then fluorescent green from the outer edges, gradating toward the head.

Step Six

Cut an acetate mask to cover everything but the flesh tones and spray very light layers of red, yellow and blue until you achieve a skin tone that you like.

Chapter 11

RETOUCHING PHOTOGRAPHS

Photo retouching is a process that uses many basic airbrushing techniques. This process generally involves increasing contrast between the subject and the background or simplifying a composition. You might remove, add or combine elements, such as distracting backgrounds, reflections or blemishes.

By simply using the frisket film or acetate, you can manipulate a photo any way you want. The techniques in this chapter work on color prints as well.

The three demonstrations that follow show monochromatic toning. As you read through the projects imagine the images retouched with color also, since the basic techniques—using masks, matching tonal values and handpainting details—remain the same. You just add color to your palette of techniques.

RETOUCHING FACTS

Any form of photography, black and white or color, print, slide or transparency, can be retouched. The opportunities are only as limited as your photo resources. Look through the prints, negatives or slides languishing around your home. Any one of these images can be retouched, although the latter two must first be made into print form.

Follow these ten professional retouching tips to ensure success:

1. Use matte-finished, not glossy, photographs because the surface accepts airbrush well and the retouching won't be visible.

2. Improve the reproduction quality of the final image by retouching on a two-time enlargement of the original image. When the retouching print is reduced for reproduction the entire image tightens up and the retouching isn't evident.

3. To retouch a black-and-white photo mix black and white watercolors to produce a range of gray tones. Add yellow ochre or burnt sienna, as needed, to warm the grays to match the particular tone of your print.

4. Dilute your paint as much as possible. Don't expect to cover a large area with the first pass. You may need multiple passes for total coverage; smooth, thin applications are best. Allow each pass to dry thoroughly.

5. Never exhibit or print from the original retouched piece, but rather make a new photograph of it and use that instead. This prevents excessive handling of the original retouching.

6. Never retouch on the only version of any photo image; always use good-quality copies of the original.

7. Have more than one print of an image so you can periodically check the accuracy of the unretouched print against your work.

8. It's best not to retouch a loose print. Dry-mount it onto cardboard or adhere it to a work surface with tape, glue, spray adhesive or tacks.

9. Always clean the print first with rubber cement thinner to remove dust and grease that might impede the application of paint or dye.

10. Clean your airbrush between applications of gray.

If this isn't your idea
of dealing with a
high pressure situation...

HOT BIKE

Paint: Gouache.
Colors: White and black.
Masking: Transpaseal film and 3mm acetate.
Surface: Black-and-white resin-coated photograph.
Plus: Bleach and rubber cement thinner.
Techniques: Airbrushing Freehand, pp. 8-19, and Using Masks, pp. 32-43.

Step One

Retouching the photograph will eliminate the motorcycle's center stand and the distracting highlights around the gas tank. It will also fade out the background to pure white. Such changes are made easier with this resin-coated print.

Step Two

Cover the photo with Transpaseal and gently cut around the motorcycle. Don't cut into the print's emulsion. Expose the background and place the print in a tray of full-strength liquid bleach. Keep an eye on the print as the emulsion will dissolve quickly. Use a soft-bristled brush to speed removal, if necessary. Rinse the print well in tap water and hang to dry.

Step Three

Remove the remaining Transpaseal from the dry print and wipe it with a soft rag and rubber cement remover to clean off residual adhesive from the masking. Cut an acetate mask to protect the motorcycle and hold it in place as you spray the drop shadows lightly with black. Edges can be softened by spraying white.

Step Four

Clean up any unsightly highlights and reflections by exposing them through handheld acetate masks and spraying a gray tint (mixed from black and white).

Step Five

Mat and frame the finished piece for display.

COMMERCIAL JET

Paint: Gouache.

Colors: Permanent white and lamp black.

Masking: Frisket film.

Surface: Black-and-white photograph.

Technique: Airbrushing Freehand, pp. 8-19, and Using Masks, pp. 32-43.

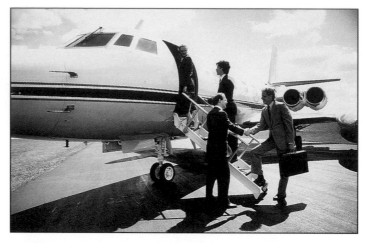

Step One

Notice how important objects in this photograph lack definition and the overall image is too contrasty. Retouching will eliminate these problems.

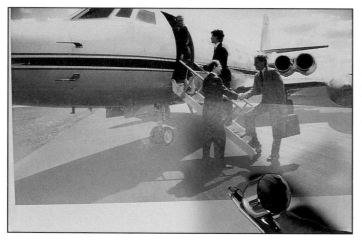

Step Two

The first step in giving form to the plane and downplaying the foreground shadows is to cover the photo with frisket film and cut around the plane and the people. Expose the foreground and cover it with a light spray of permanent white gouache.

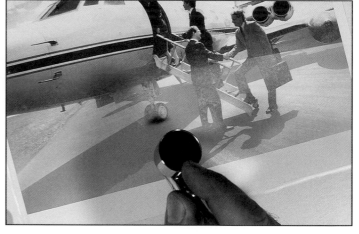

Step Three

Using lamp black, spray the dark shadows under the people and the plane's landing gear.

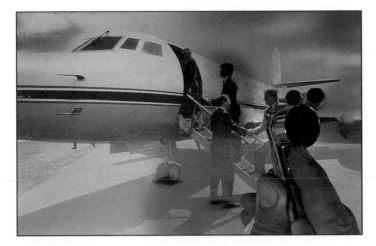

Step Four

To define the edge of the plane spray lamp black in light layers to even out the tone and darken the sky. Don't worry about masking the clouds; these will be sprayed back in.

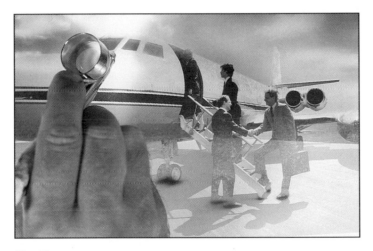

Step Five

Freehand spray the clouds using permanent white.

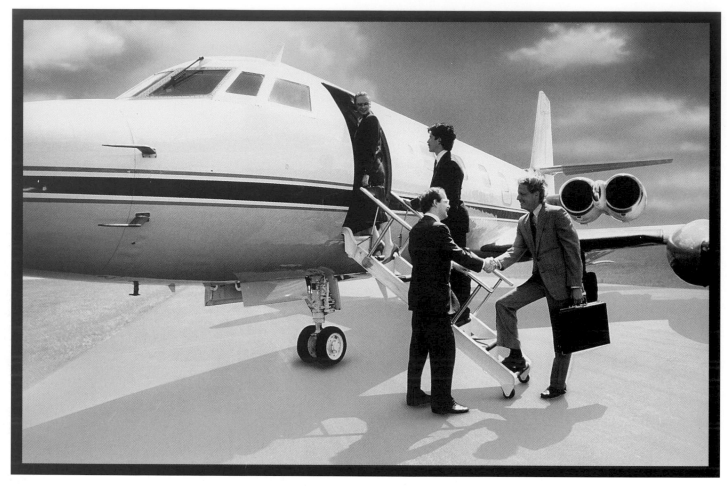

Step Six
Remove any remaining frisket film.

PERFECT PORTRAIT

Paint: Gouache.
Colors: Permanent white.
Masking: 3mm acetate.
Surface: Black-and-white photograph.
Technique: Airbrushing Freehand, pp. 8-19, and Using Masks, pp. 32-43.

Step One

First, study the black-and-white print and decide which areas need retouching. Look for unattractive shadows, such as beneath the eyes, and tones that are too similar, such as between the background and the subject.

Step Two

Dilute permanent white to a thin consistency and freehand spray beneath the eyes until these shadows are covered. To keep control of your airbrush turn the air pressure down to 10 psi and hold the brush about one-quarter inch from the surface.

Step Three

Cut an acetate mask along the shoulder and hairlines. Hand-hold the mask on the print and spray the diluted permanent white very lightly over the background to increase the visual separation between the figure and the background.

Step Four

Cut another mask to protect the subject's arms. To separate the arms from the background, repeat Step Three, this time moving the mask slightly to render a softer edge.

Step Five

Using the background portion of the mask cut for Step Three, leave the shoulder exposed and spray permanent white to add a stronger highlight to the shoulder.

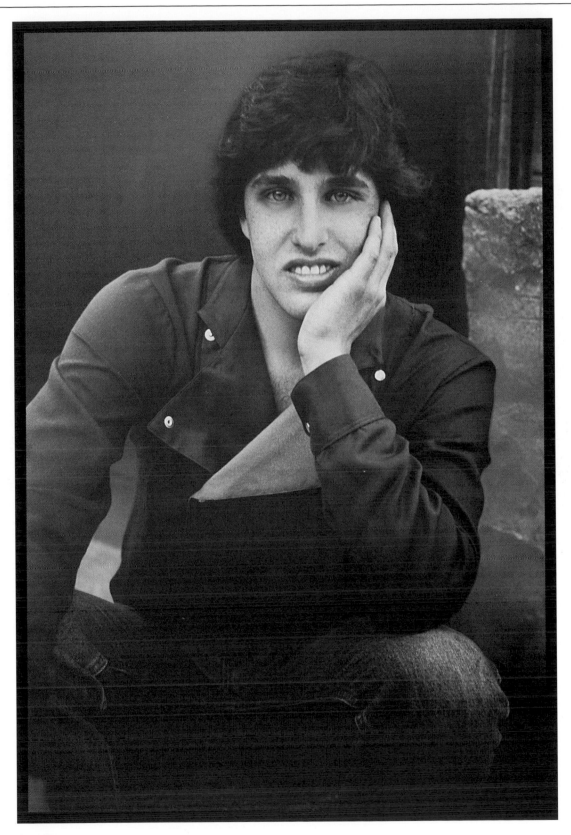

Step Six
The retouched photograph will reproduce in print much better now due to the increased separation between subject and foreground and the stronger contrast.

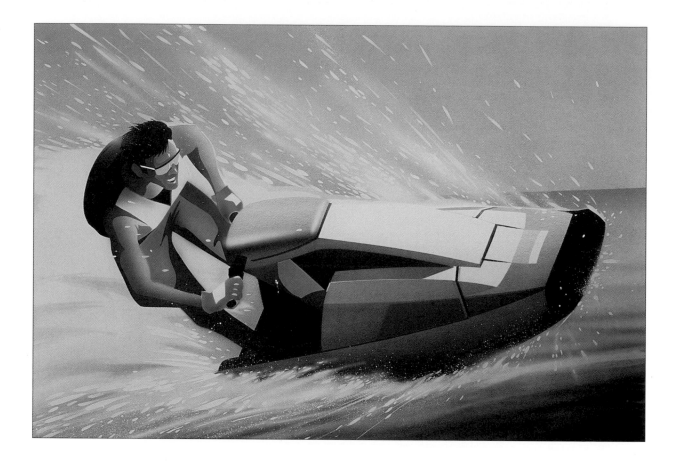

WHERE TO LOOK FOR MORE INFORMATION

Books

Dynamic Airbrush, David Miller & James M. Effler, North Light Books

The Complete Airbrush and Photo-Retouching Manual, Peter Owen and John Sutcliffe, North Light Books

Airbrushing, Carl Caiati, Tab Books, Inc.

Advanced Airbrushing Techniques Made Simple, Carl Caiati, Tab Books, Inc.

Creative Airbrushing, Graham Duckett, Collier Books

Airbrush Technique, C. Michael Mette, Taco

Airbrush: The Complete Studio Handbook, Radu Vero, Watson Guptill

The Advanced Airbrush Book, Cecil Misstear, Van Nostrand Reinhold

The Complete Manual of Airbrushing, Peter Owen and Jane Rollason, Alfred A. Knopf

The Airbrush Book, Roger W. Hicks, Broadcast Books

The Complete Airbrush Course, Roger Gorringe and Ted Gould, Van Nostrand Reinhold

Hot Air, Werner Steuer, North Light Books

Handtinting Photographs, Judy Martin and Annie Colbeck, North Light Books

Magazines

Airbrush Action, Lakewood, New Jersey

Step-by-Step Graphics, Peoria, Illinois

INDEX

air pressure,
14, 21, 24, 50, 58, 93, 115

air sources
CO$_2$ tank, 3
compressed air, 3
diaphragm compressor, 3
silent compressor, 3
spare tire, 3

airbrushes
cleaning, 6
double-action, 2
how to use, 3
selection of, 2-3
single-action, 2
turbo, 2
unclogging, 6

brushes
camel-hair, 6
dust, 6
hand, 6, 36-37, 41, 64
nylon, 6, 34-35, 70
sable-hair, 6, 39, 60-63

color, 58

commercial illustration,
description of, 2

copyright, 6

edge effects, 33-43, 45-55

effects
drop shadow, 16, 26, 89, 94,
96
lighting, 25, 43
metallic, 77-85
motion, 33, 39-42, 52-53
neon, 90-91
texture, 10-11, 24-25, 34, 52,
54-55, 57-65
starburst, 17, 27, 69, 93

equipment
acetone, 6
adhesive, 34, 48, 82
circle template, 90-91
compass knife, 70
corkboard, 6
easel, 6
erasers, 7, 37-38, 58, 60
fixative, 13
French curve, 34, 90-91
ice pick, 7
Lucidagraph, 7

Masonite, 6
non-repro blue pen, 12, 28
pounce pad, 7
respirator mask, 6
sponge, 58, 62
spray bottle, 5
stencil burner, 34
straightedge, 7
tape, 34-35, 70
toothpaste, 63
water jug, 5-6
X-Acto knife, 7, 34

formats
ads, 30, 42-43, 54, 64, 74-75,
84-85, 96, 101, 109
billboards, 31, 74
book covers, 31, 55
self-promotion, 30, 54-55, 65,
84, 97, 101

highlights, 13, 16, 22, 27, 29, 33,
36-37, 41, 47, 49-50, 53, 67-75,
83, 93, 95

ideas
sketching of, 6-7
sources of, 6

lettering, 14-15, 23, 26-27, 31,
79-81, 84-85, 87-97

masking materials
acetate, 5, 28-29, 33-42, 48, 62,
70-73, 90-91, 100, 104-105
ellipse template, 75
frisket film, 5, 7, 28-29, 33,
60-62, 70-72, 81, 90-91, 100,
102-104, 112
liquid frisket, 5, 34, 42, 70
paper, 81
stencils, 5, 34, 46
Transpaseal, 34, 110

media
colored pencils, 4
markers, 7
pastel, 19
pencil, 7
photocopy, 82
vine charcoal, 7, 14-15, 24-27,
52
watercolor, 82

paints
acrylic, 4
acrylic fabric, 5, 14-17, 24-27,
52-53, 92-95

dye, 4, 102-105
fluorescent, 6, 12-13, 39-41,
70-71, 82-83, 92, 104-105
gouache, 4, 12-13, 28-29,
36-41, 48-51, 60-63, 70-73, 82,
90, 100, 104-105, 110-117
watercolor, 4
white, 4, 6

sketch transfer techniques
color-coded method, 7
direct sketching, 7, 28
freehand spraying, 7, 12
lead pickup, 7, 39
pouncing, 7
sketch projection, 7

sketching techniques
grid, 6-7
photocopy enlarging, 7
projection, 7
tracing, 7, 36

spraying distance, 4, 12, 14, 16,
22, 24, 26, 48, 52-53, 115

subject treatment
animals, 10, 12-13, 19, 52-53,
55, 60-61, 65, 75, 97
beach, 48-51
buildings, 31
celebrities, 19, 54, 75, 92-95
clouds, 10-11, 31, 46, 113-114
cork, 58-59, 62-63
eyes, 11, 36-38, 47, 59, 69
fabric, 35
faces, 18, 36-38, 46, 54,
104-105, 115-117
fashion, 65
feathers, 13, 19, 52-53, 58-61
flowers, 18, 22, 28, 55
food, 14-15, 31, 43, 74
glass, 35, 62-63
ground, 19
hair, 11, 37
jet skier, 39-41
landscape, 19, 24-27, 30, 43,
48-51
liquid, 62-63
fantasy, 55
mouths, 35-38, 46
musical instruments, 64, 74
nature, 75
people, 18, 42-43, 48-51, 64-65,
102-103, 109
sand, 24-27, 50, 58, 64
sky, 21-23, 25, 30-31, 48-51,
60-63

snowman, 54
sports equipment, 30
starbursts, 17, 27, 69, 93
stars, 31
sunglasses, 69, 104-105
sunset, 21, 24-27, 48-51
toy, 70-71
vehicles, 72-73, 78-79, 82-84,
102-103, 110-114
water, 35, 39-42, 48-51, 68,
70-71, 102-103
windsurfer, 42
wood, 19, 58-59, 64

surfaces
board, 5, 7, 12-13, 28, 34, 36,
39, 48, 58, 60, 62, 70, 72, 81
paper, 82
T-shirt, 5, 14-17, 24-27, 52-53,
94-95

T-shirt art, description of, 2

techniques
burnishing, 7
dry brush, 58, 65
erasing, 37, 58, 68
freehand spraying, 9-19,
24-29, 36-41, 46, 48, 61-62,
68, 70-73, 82, 90, 92-95,
104-105, 113, 115
gradating color, 21-31, 36-37,
47, 49, 60-62, 78-85, 90, 94,
96-97, 102, 104-105
handbrush, 19, 61, 63, 65, 69,
83
handtinting, 99-105
heat press, 6, 53
masking, 5, 7, 18, 28-29, 33-43,
46, 48-51, 58, 60-62, 68-73,
80-83, 89-91, 102-105,
112-116
overspray, 13, 16, 53
photo retouching, 34, 107-117
sketch transfer, 7
sponging, 19
stippling, 58, 63-65